IMAGES
of America
GUYMON

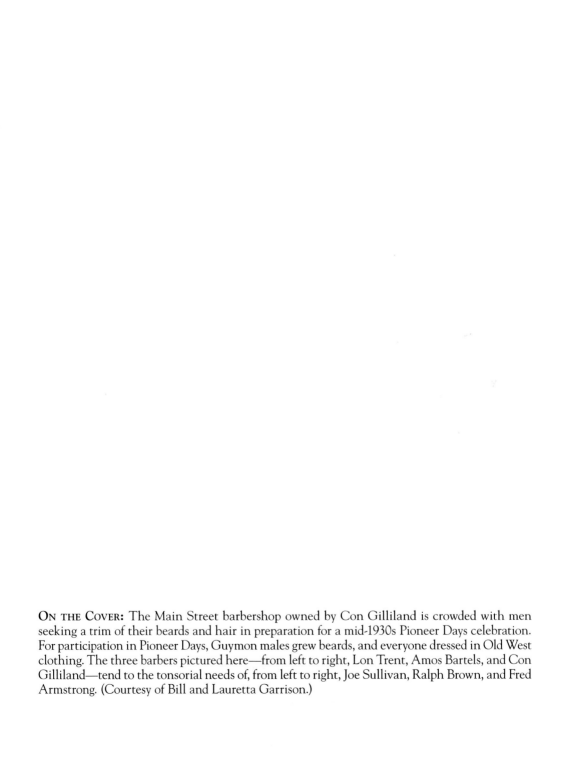

ON THE COVER: The Main Street barbershop owned by Con Gilliland is crowded with men seeking a trim of their beards and hair in preparation for a mid-1930s Pioneer Days celebration. For participation in Pioneer Days, Guymon males grew beards, and everyone dressed in Old West clothing. The three barbers pictured here—from left to right, Lon Trent, Amos Bartels, and Con Gilliland—tend to the tonsorial needs of, from left to right, Joe Sullivan, Ralph Brown, and Fred Armstrong. (Courtesy of Bill and Lauretta Garrison.)

IMAGES
of America

GUYMON

Sara Jane Richter

To the Georges
Thank you for
your support.
I hope you enjoy
my book!
SaraJaneRichter
Aug 2014

ARCADIA
PUBLISHING

Published by Arcadia Publishing
Charleston, South Carolina

Printed in the United States of America

Library of Congress Control Number: 2013951481

For all general information, please contact Arcadia Publishing:
Telephone 843-853-2070
Fax 843-853-0044
E-mail sales@arcadiapublishing.com
For customer service and orders:
Toll-Free 1-888-313-2665

Visit us on the Internet at www.arcadiapublishing.com

*I dedicate this book to my greatest supporters and the people
I love the most—Kevin and Debbie and Tito—and to the
two best university professors who ever inspired a student:
Dr. William Snodgrass and Dr. C.T. "Tibbie" Shades.*

CONTENTS

ACKNOWLEDGMENTS

I would greatly like to thank my friends and neighbors who helped me during the creation of this book. The first person on the list is Tito Aznar, the photograph and computer guru without whose help the manuscript would not have been completed. In addition, the following folks deserve special recognition for their unflagging support, kind generosity, and good cheer in the process of my gathering the photographs and penning the text: Marjie Lobit, Sharon Morgan, Dana Tomlinson, Melyn Johnson, Dean and Joann Kear, Carroll and Leonene Gribble, Rachel Sides, Beth McKee, Dean McFadden, Joann and Mike Holland, Lauretta and Bill Garrison, LeAnn Nickeson, Linda and Rex Lear, Butch Jarvis, Jihad' Wright, Sheila Blankenship, Nancy Davis, David Watkins, Tyler Koonce, Kelsey McMurry, Sue Weissinger, and Linda Hugghins. My apologies if I have slighted anyone.

Just as I expected, citizens of Guymon responded to my request for photographs and provided me with many images and historical tales. Their willingness to share their personal and community histories and family photographs meant a great deal to me. To tell the truth, it was difficult to determine which images to include here. For those Guymonites' thoughtfulness, generosity, and patience, I am very grateful.

Special appreciation goes to my employer, Oklahoma Panhandle State University, especially Dr. David Bryant, president, and Dr. Wayne Manning, vice president of Academic Affairs and Outreach, for allowing me the time and the privilege to work on this text during the academic year.

I have lived and worked in the Oklahoma Panhandle since 1985 and have lived in Guymon since 2006. I have never regretted my decision to reside in Guymon and am proud to call Guymon "home."

INTRODUCTION

Sitting on 7.3 square miles, Guymon is the largest town in the Oklahoma Panhandle. It is located nearly smack-dab in the middle of the Panhandle, a piece of real estate measuring 167 miles long and 33 miles wide, totaling 6,000 square miles. Guymon serves as the county seat of Texas County, the middle of three counties that constitute the Panhandle. Unique in the United States, the Oklahoma Panhandle, amid the High Plains, touches four states: Kansas, Colorado, New Mexico, and Texas.

Because Guymon is close to other states, and because it is the biggest community within a 50-mile radius, rural citizens of those neighboring states often come to Guymon for shopping, entertainment, medical attention, and supplies. Guymon has the staple businesses that people gravitate toward nowadays: Wal-Mart, Holiday Inn Express, Merle Norman, Kentucky Fried Chicken, State Farm Insurance, and Ford Motors. Agricultural consumers find businesses such as Tractor Supply and Gigot Agra helpful. Citizens run a host of businesses, too, like furniture stores, flooring companies, restaurants, communications concerns, banks, construction companies, convenience stores, pharmacies, car-repair shops, used-car lots, and clothing emporiums.

These businesses appeal to Guymon's population, which in 2010 totaled 11,442 people living in approximately 3,600 households, housing around 2,600 families. Households earn an average income of $37,333. Nearly half (49 percent) of the populace claim ethnic backgrounds including African American, Pacific Islander, African, and Caucasian, while 51 percent of Guymon's population is of Hispanic or Latino descent, from Mexico or Latin America. The gender composition is nearly equally divided, and there is no age group larger than any other; the average age is 30. The community receives at least 250 days of sunshine each year, with an average annual temperature of 56.6 degrees. Guymon sits in the High Plains, so rain and snow are not very common. The average rainfall is less than 20 inches per year; average snowfall amounts to 15.5 inches each year.

A lot has happened in the 112 years of Guymon's life. It is governed today via a city council and city manager. Because it sits at the crossroads of US Highways 412, 54, 64, and 280 and Oklahoma State Highway 3, Guymon experiences a lot of tourist and truck traffic. While some people complain that there is nothing to do in Guymon, there are in fact a multitude of attractions, including the summer farmers' market, the Sunflower Art and Wine Festival, the Doc Gardner Memorial Rodeo, Pioneer Days, the Pumpkin Patch Crafts Festival, the Five-State Poker Run, Relay for Life events, Azuma: An African Celebration, the Christmas parade, Sunset Hills Golf Course, Sunset Lake, and Thompson Park.

Guymon in the 21st century is a typical Southwestern, agriculturally based community with its eyes on the future, serving a unique population. It has grown and changed since the last quarter of the 20th century, not always smoothly or comfortably. However, that growth and change have made Guymon an eclectic and dynamic community that caters to the five-state area and its population.

One

THE HISTORY OF GUYMON

Guymon sits on flat land that rises to low hills north of town. Incorporated in 1901, Guymon has meant much to the High Plains and to the strong-willed people who carved a living from a harsh terrain and a severe climate.

Panhandle history began in the 1880s when homesteaders settled in what is now Cimarron, Texas, and Beaver Counties of Oklahoma. In 1901, the Rock Island Railroad built a line from Liberal, Kansas, southwestward toward Tucumcari, New Mexico. In 1907, Oklahoma Territory became Oklahoma, and the stage was set for real Panhandle development.

Guymon started with Edward Guymon. Born in Coatsburg, Illinois, in 1859, Guymon heard the call of the West and worked westward. Initially, he settled in McPherson, Kansas, and worked in a grocery store and for the railroad. Wanting his own business, he followed the railroad in the late 1880s, settled in Liberal, Kansas, and opened a grocery in 1888. He believed that his fortune lay in the Panhandle, called "No Man's Land," which had no law and few settlers, so he purchased a section of land in the 1890s where he thought the railroad would need a stop.

The town plat was drawn in 1900. Then, Guymon established a land company with himself as president. He and two partners sold 160-acre parcels of land beginning on July 16, 1900. Guymon never viewed his land company as a way for him to become a real estate mogul, for he wanted to build businesses to provide provisions and support for his fellow pioneers. For example, he established a general store and a lumber company and served as the first president of the Beaver County Bank, today known as the City National Bank and Trust.

Settlers lived in the town, first dubbed Sanford, but the railroad believed the name was too similar to that of a Texas community 50 miles to the southwest: Stratford; therefore, in June 1901, Sanford became Guymon. With a population of 350, Guymon started its life. O.S. Jent served as the first mayor; L.B. Sneed was the first town clerk.

It did not take long for Guymon to flourish—as much as a fledgling community can in No Man's Land at the turn of the 20th century. Businessmen saw Guymon as a place with a future, and photographers, newspapermen, cobblers, millers, and liverymen quickly set up storefronts.

The Beaver River cannot really be called a river today, but in an earlier time, it provided habitat for wildlife, water for livestock, well water for settlers, and irrigation for crops in the Oklahoma Panhandle. Through the ages, the river has created gentle, rolling, low hills for its passage. The town of Guymon developed on the south side of the Beaver River at the turn of the 20th century. It is clearly evident that only the bed can be seen, even in the "rainy" season. (Courtesy of Tito Aznar.)

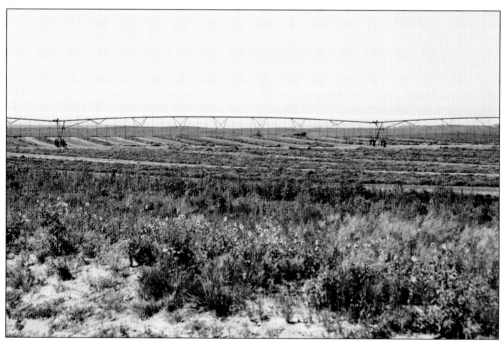

Besides ranching enterprises, farming is an important part of Panhandle life. Irrigation using pivoting sprinkler systems, as seen here along the horizon, benefits agricultural production. Crops such as wheat, corn, maize, and cotton, along with ranching production, help make Texas County, of which Guymon is the county seat, one of the top 10 agricultural-producing counties in the United States each year. (Courtesy of Tito Aznar.)

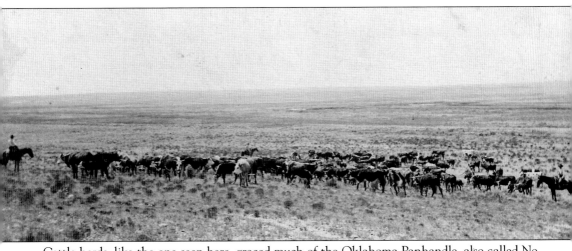

Cattle herds, like the one seen here, graced much of the Oklahoma Panhandle, also called No Man's Land, in the late 1800s and early 1900s; they still do. Terrain, climate, and vegetation combined perfectly for cattle companies to raise livestock. Ranching and its associated businesses, like feedlots, farm and ranch supplies, hay, and veterinarians, have always been integral elements of Panhandle life. Area ranches, such as Hitch and Anchor D, have storied pasts. This roundup of bovines occurred on the Stonebreaker Ranch near Guymon in the late 1880s. (Courtesy of Guymon Public Library and Arts Center.)

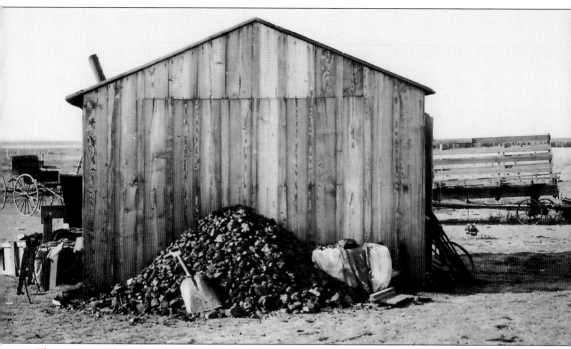

This is a typical settler's shack on the High Plains in the late 19th century. Along with shanties like this, many pioneers lived in dugouts carved into the sides of creek and stream banks, like Pony Creek and Coldwater Creek, or simply dug into the ground. Because of the dearth of trees for construction, some settlers lived in sod houses made with strips of sod and grass and dirt stacked into the shape of a house. The pile of coal at the rear of this shack would provide heat and a cookstove fire for the folks who lived inside. Certainly, heat was needed as the flat land of the Panhandle did not stop the winter wind from sweeping down the plain and whistling between the planks of the walls. (Courtesy of Lobit Studio.)

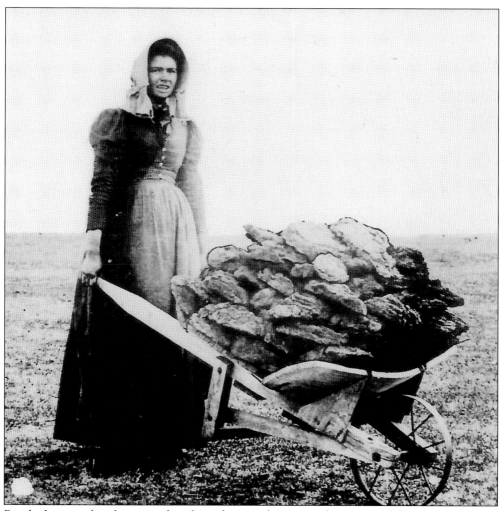

Besides heating their homes and cooking their meals using coal, pioneers of the American Great Plains utilized a common source of fuel: chips. These chips, including cow chips, buffalo chips, and horse chips, were simply dried animal dung. Fires made from this fuel burned quickly and intensely. Gathering the chips did not really bother those, usually women and children, who performed this task on the prairie. What lived under the chips was the most distasteful part of the process, for centipedes, spiders, snakes, and other creepy things were constant surprises. Like the haggard woman pictured here, the pioneers who settled the Panhandle had much to overcome; however, they were creative and stalwart enough to be successful and bring civilization to a raw, rough and ready place. (Courtesy of Lobit Studio.)

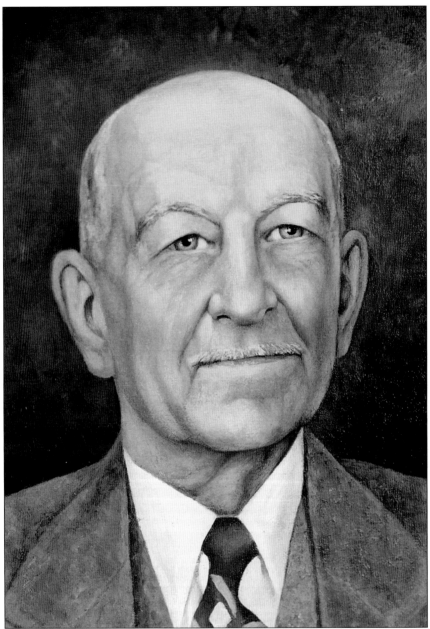

Edward Tyndal "E.T." Guymon believed that he could make his fortune in No Man's Land as the century turned. He had been in the grocery and lumber business in McPherson and Liberal, Kansas. Once the Rock Island Railroad laid trackage into the Oklahoma Panhandle, Guymon purchased materials to establish a general store, Star Mercantile, and a lumberyard, Star Lumber. This location, where the trackage ended, was originally known as Sanford. Within months, the rail stop was renamed "Guymon" because the railroad agent said that no one got any freight except for E.T. Guymon. Among other accomplishments, Guymon became the first president of the Beaver County Bank, which is today City National Bank and Trust. In addition, he developed the Inter-State Land and Town Site Company, which sold lots to future Guymonites. This portrait of Guymon was painted by Valentine Morse. (Courtesy of Pioneer Showcase.)

Once E.T. Guymon set his sights on establishing a settlement along the Beaver River, he needed a land corporation to sell property. To accomplish that, he needed a surveyor; enter T.O. James, the man who surveyed the original 160 acres purchased by Guymon. This site became Guymon, in the county of Beaver, in the territory of Oklahoma, in 1901. (Courtesy of Pioneer Showcase.)

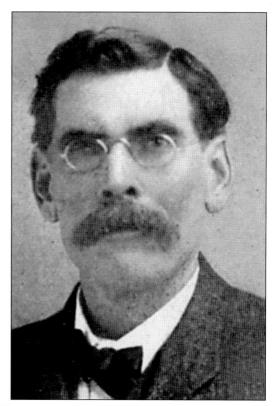

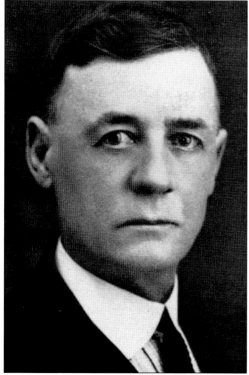

The third "father of Guymon" is Richard B. "Dick" Quinn. In 1890, Quinn edited the *Hardesty Herald* in Old Hardesty, about 20 miles southeast of Guymon. After the establishment of Guymon commenced, Quinn loaded his printing equipment onto wagons and drove them to Guymon to start a newspaper there. Once the townsite was established and surveyed, the president of the townsite and sales company, E.T. Guymon, hired Quinn as the town corporation's secretary. (Courtesy of Pioneer Showcase.)

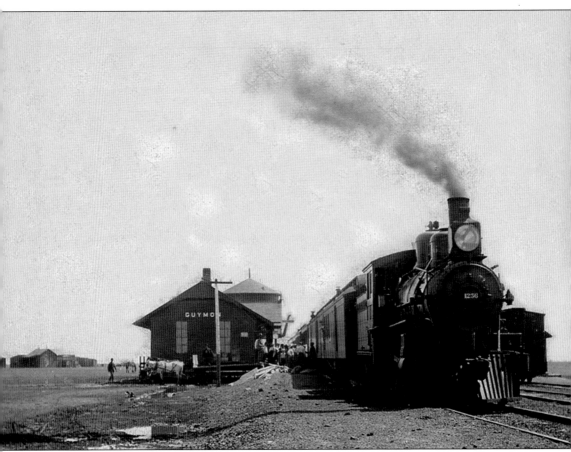

The Rock Island Railroad ended in Liberal, Kansas, and 13 years later crews built tracks to Guymon, heading southwest to Tucumcari, New Mexico. The railroad decided to build toward New Mexico rather than south toward Amarillo, Texas. This decision upset communities like Old Hardesty. People had assumed that the railroad would build into Texas. This 1901 photograph shows the first passenger train to arrive in Guymon. A new town was conceived and nurtured by the railroad. The wide expanse of the Panhandle's flat terrain is obvious here. The 72 miles of trackage heading southwest from Guymon to Middle Water, Texas, runs on a tangent and is the longest stretch of straight railroad tracks in the United States. (Courtesy of Pioneer Showcase.)

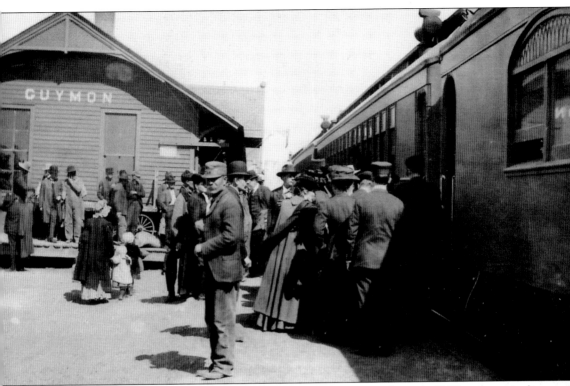

This photograph captures a daily scene witnessed in most towns in the early 1900s—the arrival of the passenger train. Guymon's depot saw many travelers, including immigrants, come and go. In early photographs, immigrants often stand out as their headgear differs from Americans' hats. Note that the man in the foreground is wearing a leather cap common to immigrants. Americans, on the other hand, wore fedoras or Western hats. Immigrants from Ireland, Russia, Czechoslovakia, Germany, and France arrived in the Panhandle. Interestingly enough, 100 years later, history repeated itself when immigrants from Latin American and African countries came to Guymon to find employment in the local meatpacking industry. (Courtesy of Pioneer Showcase.)

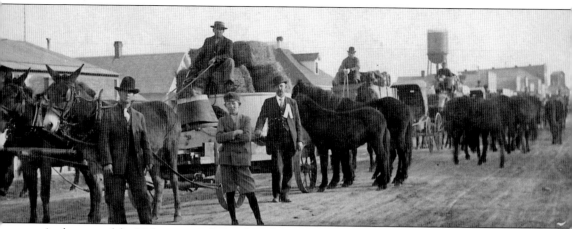

At the turn of the 20th century, the Panhandle was prime land for pioneers who wished to engage in farming and ranching. This photograph, taken in March 1910, shows how the L.W. Shields family and its nine children moved from Kansas to Guymon to begin a new life. Their livestock came shipped on a railcar, and their personal belongings, including hay for their animals, traveled by wagons. L.W. Shields purchased land for his family's homestead about 10 miles north of present-day Guymon from J.R. Nichols's land company. (Courtesy of Dean and Joann Kear.)

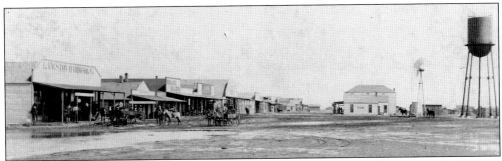

Guymon started its life in 1901 as Sanford. The name was soon changed because the Rock Island Railroad wanted to differentiate between Stratford, Texas, and Stanford, Oklahoma Territory. Here, Guymon's Main Street shows a typical High Plains settlement of several wooden structures that house businesses and the important water well and tower. Even early on, Guymon was the lone source of entertainment and commerce along the Beaver River in No Man's Land. (Courtesy of Guymon Public Library and Arts Center.)

The first water tower to provide water for public consumption and steam train engines was erected near the railroad tracks in 1909 and stood 80 feet tall. This popular image appeared on many postcards purchased in Guymon and mailed to distant locations. Today, Guymon is served by three water towers in various parts of town. This tower was dismantled years ago. (Courtesy of Lobit Studio.)

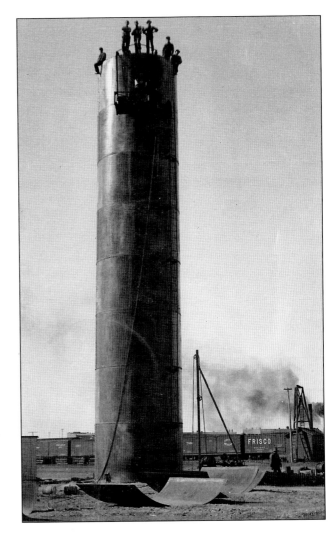

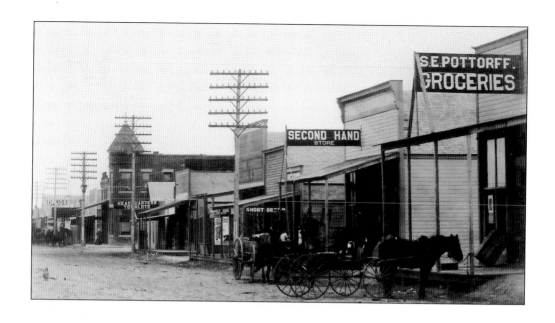

The photograph above depicts Guymon's Main Street in 1908 when the town was only seven years old. The building with the cupola on the left is the First National Bank. In 1912, most of Guymon's Main Street businesses burned down in a fire with an estimated loss of $25,000. Results of that disaster, seen in the photograph below, prompted businessmen to rebuild their structures using red brick rather than wood. This decision resulted in a stronger, more attractive, more modern-looking business district. The first establishment to use brick was C. Summers and Sons. (Above, courtesy of Lobit Studio; below, Hurliman Collection, No Man's Land Museum.)

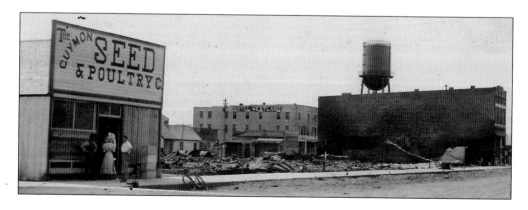

Guymon's redbrick buildings persisted until the mid-20th century; then, many Main Street businesses refurbished using blond brick to achieve a unified appearance. In the 1960s, businessmen fronted their stores with metal awnings and facades, again reinventing the Main Street look to be more current, as shown in the photograph above. Many contemporary storefronts have fabric awnings for beauty and for shade. One of Guymon's calling cards is its redbrick streets, too. Those hand-laid bricks sit on sand and provide a rumbly, old-school charm to the streets of downtown. The photograph below of modern-day Main Street looks north from the west side of the Texas County courthouse. An early tourist appeal stated, "Guymon, the queen of the prairies and gateway to the nation's playgrounds, invites the world to her gates." That slogan still speaks volumes. (Above, courtesy of Lobit Studio; below, Tito Aznar.)

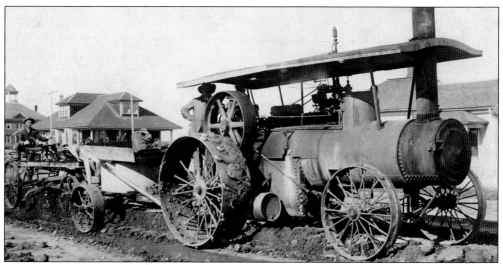

In this early photograph of city maintenance efforts, W.C. Ondler grades a street by pulling a road grader with a tractor. In February 1910, Ondler graded the 10 miles of Guymon streets to provide smooth passage for a newfangled invention: the automobile. In 1908, there were already 16 cars in town, and the local newspaper boasted that more drove in each day. By 1918, most of Guymon's streets had been paved. (Courtesy of Guymon Public Library and Arts Center.)

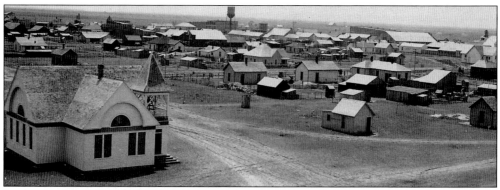

Looking rather forlorn and isolated here, Guymon is about a decade into its life. Those unpaved streets are clearly seen. To get the entire town in view, a brave photographer from McQuillan Photography Studio carried his camera equipment to the top of the Guymon schoolhouse. Note the cupola of the First National Bank in the upper left. The first Baptist Church is the left foreground. (Courtesy of Dean and Joann Kear.)

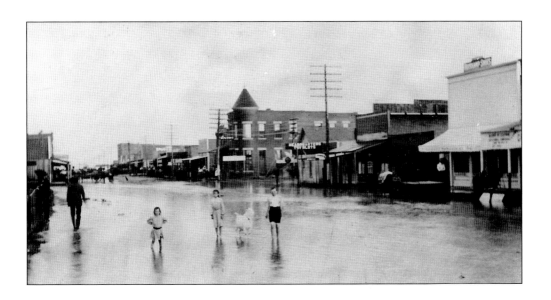

Contrary to what most non-Panhandle citizens believe, it really does rain in this part of Oklahoma. The 1903 flood shown above proves just that. Because of poor drainage and a lack of sidewalks and paved streets, Guymon's Main Street became a quagmire almost any time it rained. Big snows also hit the Panhandle, as occurred in 1957 and 2011. The snowstorm shown below came in 1912. Driven by fierce blizzard winds, snow blows around and gets deep quickly. However, one of the wonderful things about the Panhandle is that rain and snow evaporate and melt quickly in the dry air of the High Plains. (Above, courtesy of Lobit Studio; below, Pioneer Showcase.)

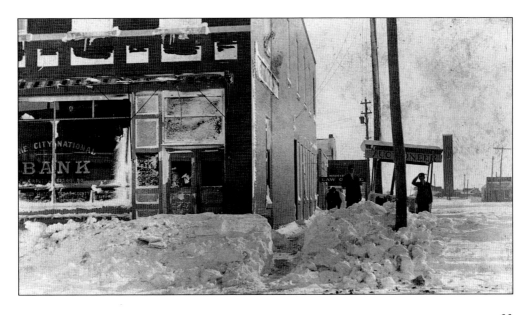

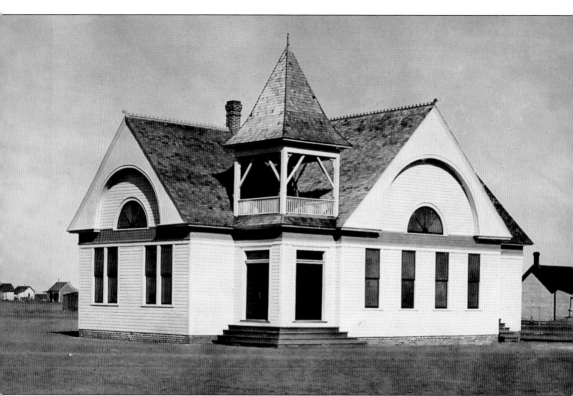

The Baptist congregation organized itself in the Woodsman Hall inside the Willoughby Hotel on November 16, 1903, with J.M. Newman as the pastor and Harry Hunt as the Sunday school superintendent. Newman earned $50 a month and a parsonage for him and his family. The janitor's salary amounted to $5 a month in the summer and $7.50 a month in the winter. Initially, Methodists generously shared their church with the Baptists two Sundays each month. By July 1906, the Baptists had constructed their own church for $482 on land donated by the city. That church, shown here, was dedicated on December 30, 1906. O.J. Cole served as the minister. Early on, parishioners followed strict rules: no dancing, no card playing, no alcohol, and no shady business deals. (Courtesy of Guymon Public Library and Arts Center.)

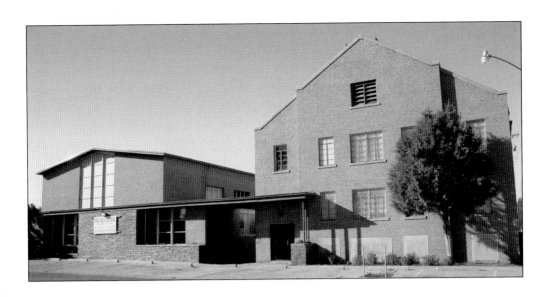

In 1952, half a century after the first church was built, the Guymon Baptist congregation and its pastor, M.J. Lee, financed another multistory edifice (above). Since 2001, that building has been used by the Hispanic Baptist congregation, for members built a third, still larger church in town. Situated in the northeast part of Guymon, the newest First Baptist Church (below) was built and then dedicated in 2001 when Derek Cox was the pastor. Between 1903 and 2001, twenty-four pastors have filled the pulpit at this church. (Both, courtesy of Tito Aznar.)

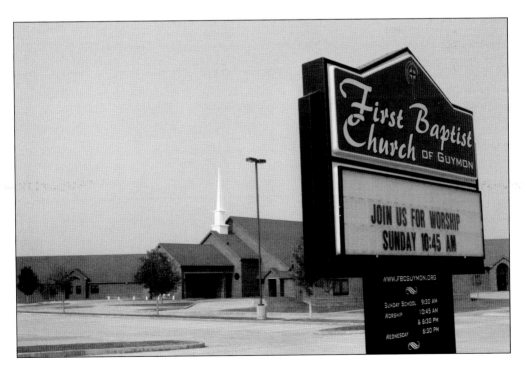

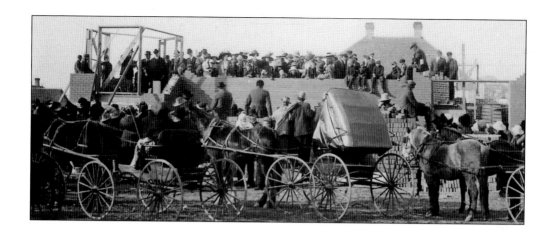

In 1888, Mary Hitch sent an impassioned letter to Rev. A.P. George, asking for a Methodist minister to develop a church in the Panhandle. E.F. Reser volunteered to serve as a circuit preacher, and the first Methodist service was held in Guymon at the Rock Island Depot in 1902. A church was built only a year later. Graciously, the Methodist congregation shared it with members of other faiths. Another, larger Methodist church was built for $16,000 in 1912. The photograph above shows the laying of the church's cornerstone. The image below depicts the completed Methodist Episcopal Church, which was dedicated in August 1913. (Both, courtesy of Lobit Studio.)

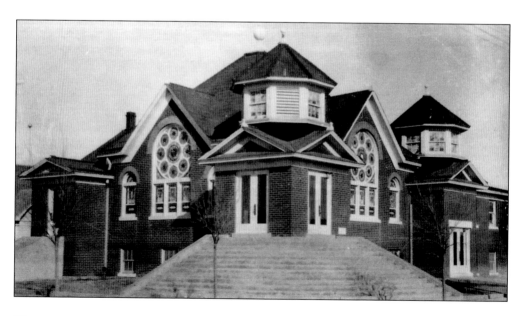

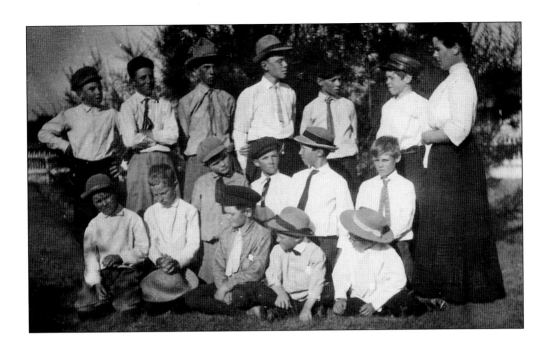

Above, an early-day Methodist Sunday school class of young boys poses with their teacher. After World War II, Methodists saw a need for a larger structure. Under the guidance of their pastor, H.G. Butler, another church was erected and then dedicated in 1950. The new church, below, was named Victory Memorial in recognition of the many parishioners who served during World War II. (Above, courtesy of Dean and Joann Kear; below, Tito Aznar.)

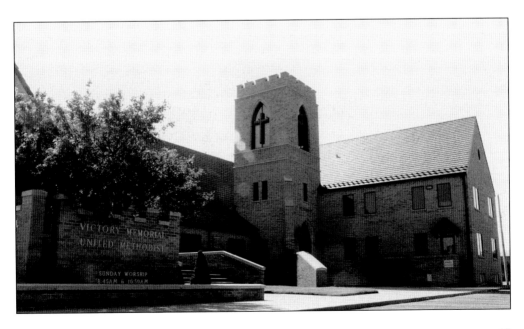

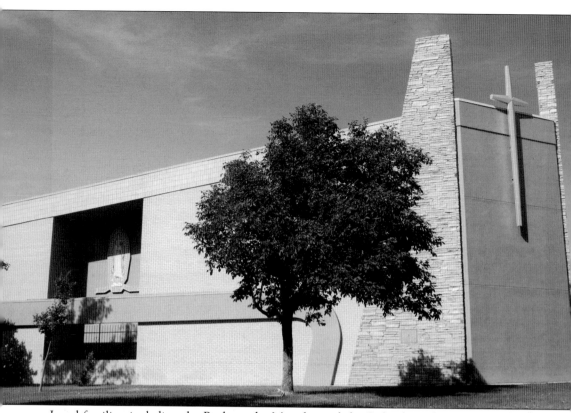

Local families, including the Beckers, the Matzeks, and the Sofrankos, plus Fr. Peter Kamp of Woodward, Oklahoma, worked to establish Guymon's Catholic church in 1907. The first parish priest was Fr. Albert Monnot. Between 1916 and 1922, the priest in Dalhart, Texas, tended the Guymon flock. When Fr. Harold Pierce served in the late 1930s, parishioners built a grotto dedicated to the Virgin Mary; it was made of volcanic rocks from the Holy Land, Mexico, Canada, and 32 US states. Between 1943 and 1964, Franciscans from Ohio came to St. Peter's. A new rectory and a church with a 500-seat sanctuary were dedicated on April 22, 1985. (Courtesy of Tito Aznar.)

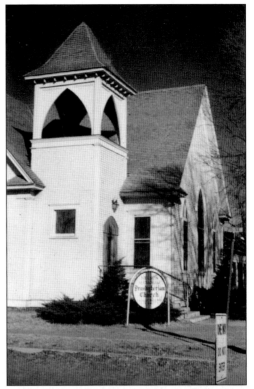

As early as 1904, Presbyterians held worship services in Guymon. They received a $700 grant from the national headquarters to build a church, and by 1916, the congregation had leased the old Methodist Church for their services. The Presbyterians purchased that church and its parsonage one year later for their own church family and pastor. It was named the Nelson Memorial Presbyterian Church (at right). In 1963, the old buildings were demolished to make way for a new place of worship (below). The congregation funded a fellowship hall north of the church in 1985 and extended paved parking in 1988. (At right, courtesy of the First Presbyterian Church; below, Tito Aznar.)

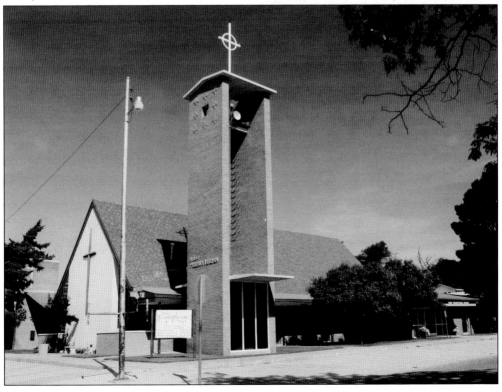

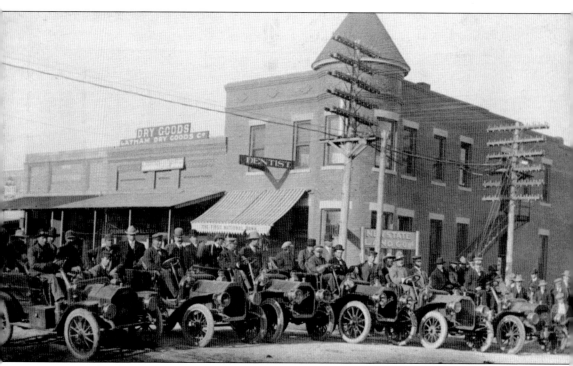

Vying to be the county seat of Texas County were three communities: Guymon, Optima, and Hooker. In an April 1909 election to determine the county seat, Guymon received 2,000 votes, Hooker got 1,900 votes, and Optima received 147. As a result, Oklahoma governor C.N. Haskell officially declared Guymon the county seat on April 29, 1909. This photograph captures part of the celebration as citizens of Guymon boast about their community's first success at playing politics. (Courtesy of Guymon Public Library and Arts Center.)

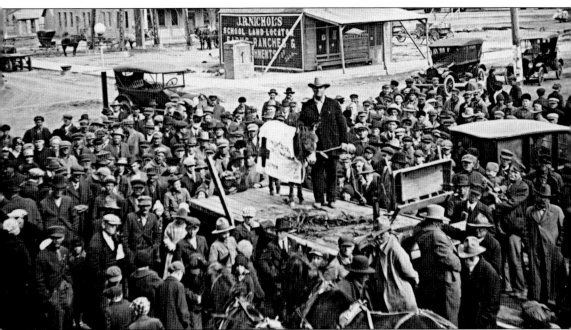

Guymonites have always been interested in helping their fellow men. In this photograph, taken on April 20, 1918, bidders and spectators gather downtown to bid on a donkey. All proceeds of the auction went to the Red Cross efforts for World War I relief. The man who bought the donkey paid $617.18, a significant amount of money in 1918. The office of J.R. Nichols, prominent real estate entrepreneur, stands in the background. (Courtesy of Guymon Public Library and Arts Center.)

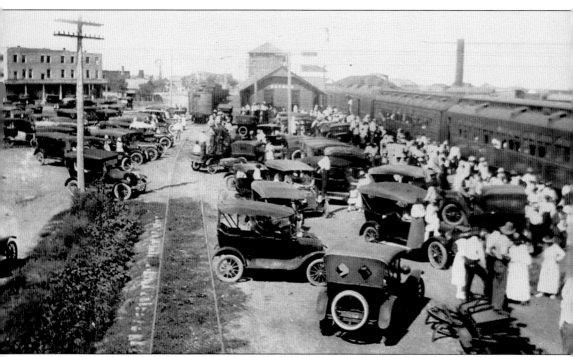

Guymon has always taken great pride in its veterans. Patriotic men who volunteered their services during World War I boarded a train at the Guymon depot in the summer of 1918. Friends, relatives, and well-wishers saw the young men off. Their military service began with training at Camp Travis, located in San Antonio, Texas. There, the men became members of the 90th Division of the US Army. (Courtesy of Pioneer Showcase.)

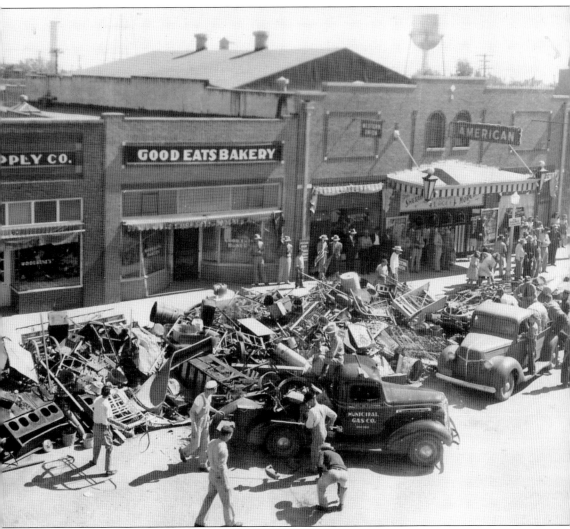

It was not unusual for communities to hold metal drives during World War II to provide the military with iron and steel used for the production of armaments. Guymon participated in this civic-minded and patriotic activity as seen in this photograph taken during the war years. Citizens brought scrap metal and broken implements to Guymon's Main Street so that it might be picked up, recycled, and used for national defense. This pile of metal stretched for one full city block. (Courtesy of Mike and Joann Holland.)

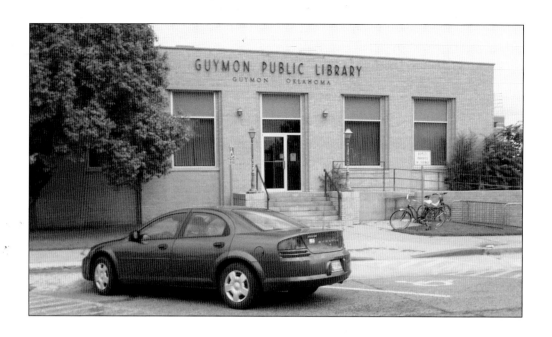

Mrs. F. Hiner Dale started Guymon's first library out of her home in the 1910s. Later, it moved to a building on Fourth Street before going to the county courthouse and then to city hall. In 1967, a new post office was built, so the library moved into the old post office, constructed in 1938 (above). The newest library (below) opened in September 2013. The architecturally unique building also contains genealogical research archives; children's reading and activities sections; and meeting, board, and safe rooms. Funding from the US Department of Agriculture came in the form of a $4.6 million grant. This building, like the new fire station and new animal shelter, had been debated since the mid-1990s. Whatever expense these additions have cost citizens, they add modernity and contribute to the community's quality of life. (Both, author's collection.)

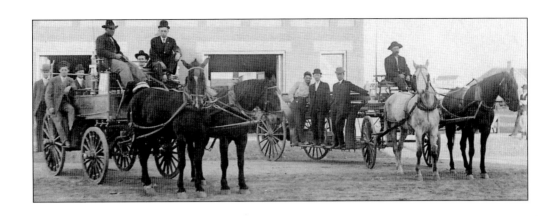

Guymon's fire department has come a long way since the days of horse-drawn firefighting equipment. In the photograph above, taken in 1912, fire chief George Ellison wears a derby. Currently, Guymon has two fire stations. Below, Fire Station No. 1, the new one, sits on the north side of town where Guymon has seen the most growth. Guymon's north side had no nearby station, and the department needed a place to store equipment and several trucks, including a new ladder truck. This $4.6 million project was built amid controversy regarding design and cost. Ground-breaking occurred on June 12, 2012, and the eight-bay station opened in August 2013. (Above, courtesy of Dean and Joann Kear; below, Tito Aznar.)

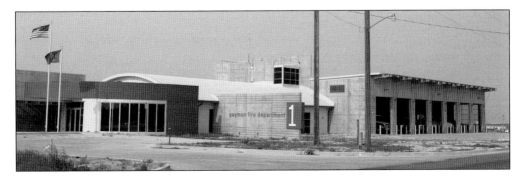

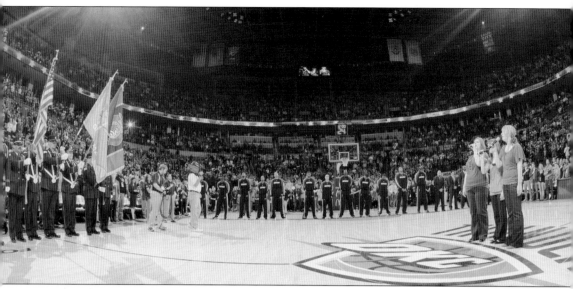

Today, the Guymon Fire Department (GFD) has state-of-the-art equipment and an impressive statewide presence and reputation thanks to its hazardous material–disposal team and disaster team. These units respond to Oklahoma calamities, such as the 2012 Woodward tornado. Here, the GFD honor guard (left) presents the national colors at a 2012 game of the Oklahoma City Thunder of the National Basketball Association. (Courtesy of Dean McFadden.)

In addition to the new fire station and library, another construction project was recently completed. The Ed and Mary Nash Animal Shelter is located on the north side of town. Guymon debated the necessity for a new animal shelter for many years. On April 26, 2012, the city council approved construction of the building at a cost of $1.4 million. This shelter replaced one, outdated and in ill repair, that had been constructed nearly 30 years earlier. The new shelter's name honors a Guymon philanthropic family, Ed and Mary Nash, and its family foundation, The Nash Foundation. (Courtesy of Tito Aznar.)

Because no government had official control of the Oklahoma Panhandle before the Organic Act became law in 1890, no mail service existed there. The earliest post offices were people's homes, and homeowners took it upon themselves to make sure that mail got delivered to the addressees. Mary Wilson came to Guymon, opened a hotel, began a restaurant, and worked with E.T. Guymon to deliver the mail from an office on Fifth Street (above). The First National Bank served as the post office six years later (below). (Above, courtesy of Lobit Studio; below, Pioneer Showcase.)

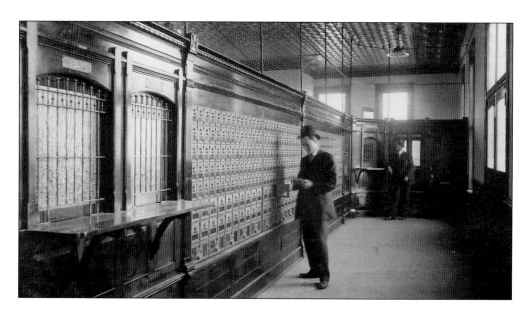

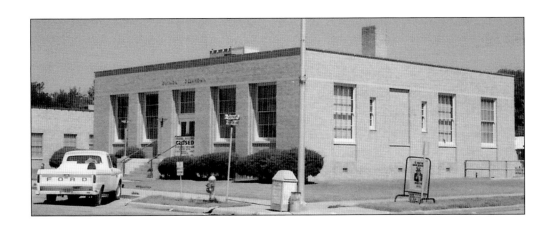

Finally, Guymon deserved a new post office, building one at a cost of $37,000 in 1937 (above). At the time, Frank DeWolfe served as postmaster. The current post office (below) was erected at the intersection of Third and Quinn Streets in 1966. From 1966 until 2013, the 1937 post office served as the town's library. (Above, courtesy of Lobit Studio; below, author's collection.)

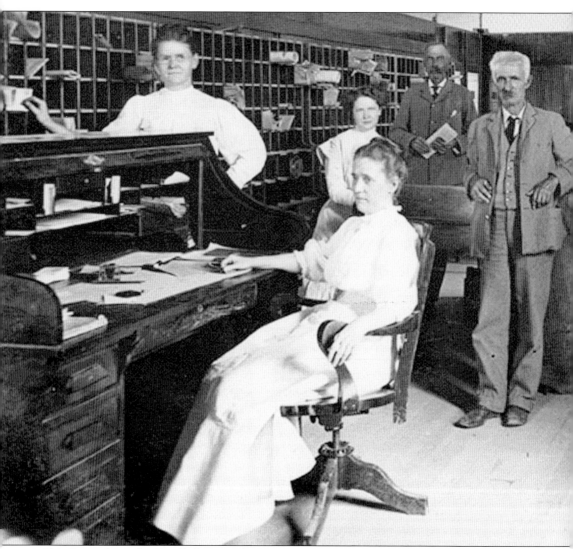

Cleo Quinn (seated) officially became the first postmistress of Guymon, Oklahoma Territory, on June 29, 1901. Prior to her appointment, Mary Wilson served as assistant postmistress, handling the mail that came to and out of Guymon at her hotel and café. (Courtesy of Pioneer Showcase.)

An immediate need of any up-and-coming community is boarding. With the number of people passing through Guymon in the early days of the Rock Island Railroad and with cowboys pushing herds of cattle to town to board the trains, Guymon needed places for people to stay on a temporary basis. It has, therefore, seen many hotels and motels. Hoteliers from the early days included M.A. Willoughby, who arrived in 1902 and opened a boardinghouse, the Willoughby Hotel (above, at right). By 1919, other hotels had appeared, like the Pike (above, at left), the Guymon, the Gross, and the three-story Park (below). (Above, courtesy of Pioneer Showcase; below, Guymon Public Library and Arts Center.)

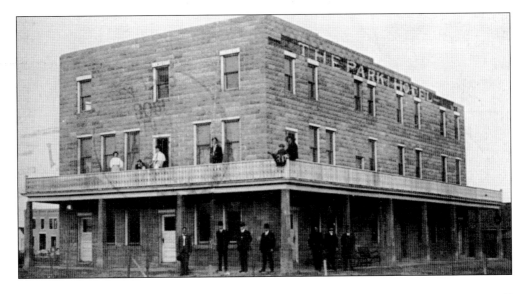

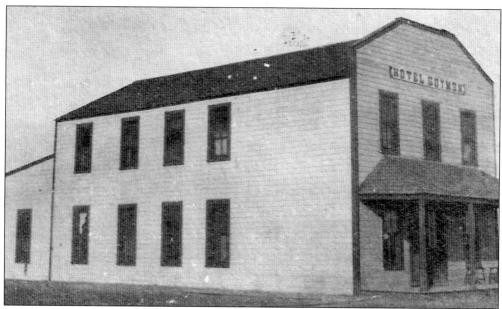

Most hotels, located close to the train depot, were brick, but the Guymon Hotel seen above was made of wood. The building shown below originally was an early-day hotel, the Pike. It underwent several name changes through the years: the Chenault Hotel, the Garst Hotel, and the Gross Hotel. It currently stands as the Oaks of Mamre, a residence for the homeless. Organized with the leadership of some local churches nearly 20 years ago, the shelter originally provided housing for people who moved to town to work for Seaboard Foods and who initially had no place to live. Now, residents may live there for up to two weeks or until they have worked and made enough money to secure other housing. Currently, a volunteer board of directors representing Guymon churches oversees its operation and upkeep. (Above, courtesy of Pioneer Showcase; below, Tito Aznar.)

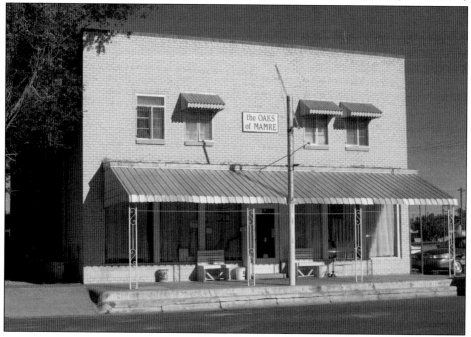

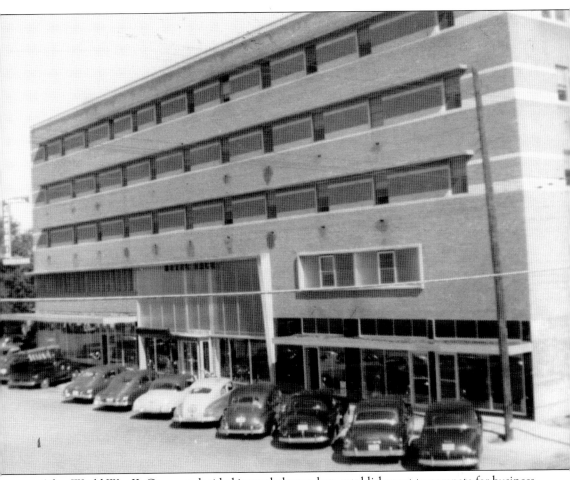

After World War II, Guymon decided it needed a modern establishment to compete for business and tourism, so the chamber of commerce initiated plans for a high-rise hotel, complete with an elevator. Judge F. Hiner Dale offered property for the location, and E.A. Lewellen built the five-story structure for $65,000. Opening in September 1950, the hotel's rooms had individually controlled air-conditioning and heating units and a fine-dining restaurant on the second floor. The hotel featured 100 rooms, each with its own tiled bathroom. Legend insists that the hotel housed prostitutes on the top floor and illegal gambling in the basement. Since 1990, Southern Office Supply has used the structure for storage. (Courtesy of Pioneer Showcase.)

By 1940, Guymon needed an airport. The Federal Aviation Administration (FAA) cited uneven terrain and rough vegetation as factors prohibiting a safe airport, but Orville Nash took an FAA official on an aerial tour. Frightened by Orville's landings and take-offs amid yucca and prickly pear, the official finally said "yes." Construction crews needed a bridge over an arroyo, but Nash thought a dam would be better and cheaper. In addition, it would allow for a lake: Sunset Lake. In 1946, the airport's runway measured 5,899 feet by 100 feet at an altitude of 3,123 feet. Because of dangerous winds, a grass runway is also available. The airport received the 2009 FAA Southwest Region Oklahoma Large Airport General Aviation of the Year Award and the 2010 Oklahoma Airport Operator Association's Airport of the Year Award. The first pilot to land in Guymon was Walter Beech in 1924. The first female to solo was Mabel Irene Noonan in 1932. She was the first female to solo west of Norman, Oklahoma. (Courtesy of Tito Aznar.)

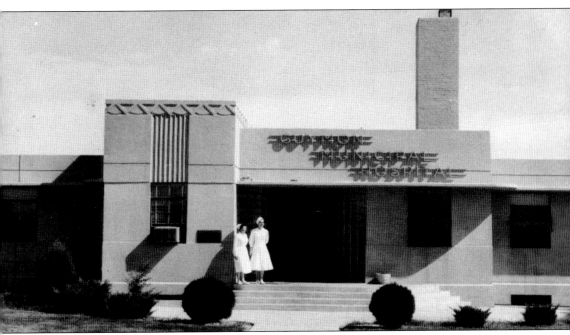

Guymon sought to establish a hospital during World War II, but little was accomplished. By 1946, efforts were renewed to develop one, and residents approved a $90,000 bond to construct a 13-bed hospital. In 1947, Guymon passed a bond for $100,000 to double that capacity. Monies from various sources helped the dream become reality at a total cost of $277,000. Doors opened to welcome the first patient on July 13, 1949. By the late 1950s, the hospital needed to expand, so the city approved a bond for $250,000 for 22 additional beds. In 1961, the facility received a new name: Guymon Memorial Hospital. In July 1969, Texas County purchased the facility from Guymon for $1, and the name was changed to Memorial Hospital. A third remodeling took place in 1972 at a cost of $140,000. In 1974, a $315,000 dietary wing was attached to the hospital's west side. It now house offices, physical therapy facilities, food service, and emergency services. (Courtesy of Pioneer Showcase.)

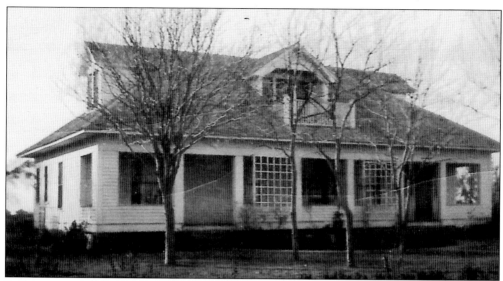

Built at a cost of $2,000, the home known as Danholt is the only Guymon site in the National Register of Historic Places. Anders Mordt, a land speculator from Norway, constructed the two-story home with eight first-floor rooms and a large game room on the second floor. Mordt named the house for his wife, Dagne; *Danholt* means "Dagne's Grove" in Norwegian. Danholt's gala opening occurred in July 1912, and all of Guymon came to enjoy punch, a three-course luncheon, and fireworks. In 1913, Mordt sold the house and moved to Chicago after his land speculation company went bankrupt due to severe drought. A gazebo (below) decorated the backyard. It has been refurbished and transplanted to the backyard of Bill and Lauretta Garrison's home. Lauretta grew up in Danholt. (Both, courtesy of Bill and Lauretta Garrison.)

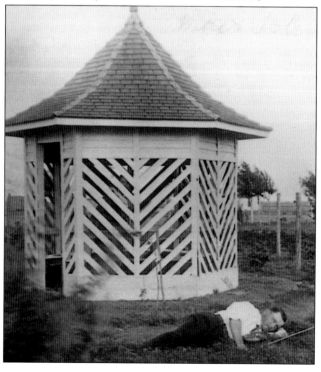

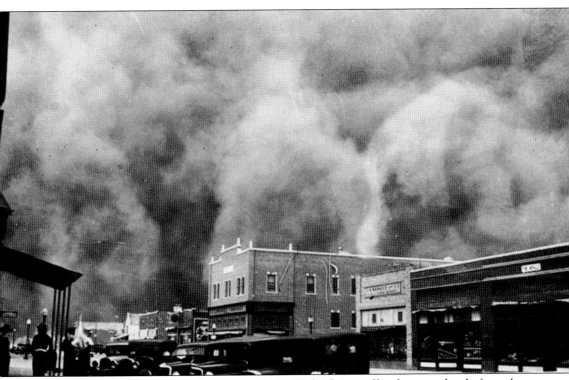

During the Great Depression, Guymon and the High Plains suffered tremendously from dust storms and drought. This photograph from the early 1930s shows a dust storm, also known as a "roller," about to swallow downtown Guymon. Darkness caused by the frequent dust storms caused streetlights to turn on and people to drive cars into trees and fences. The heavy dust gathered in attics and caused ceilings to collapse. Some, especially the very young and the very old, caught dreaded dust pneumonia and died. Others went blind because the gritty dust affected their vision. The Dust Bowl, caused by the overproduction of wheat and extreme drought, reached its zenith in the mid-1930s. Western Oklahoma and Kansas, the Texas Panhandle, northeastern New Mexico, and southeastern Colorado received the brunt of the climatic, economic, and social disaster. (Courtesy of Lobit Studio.)

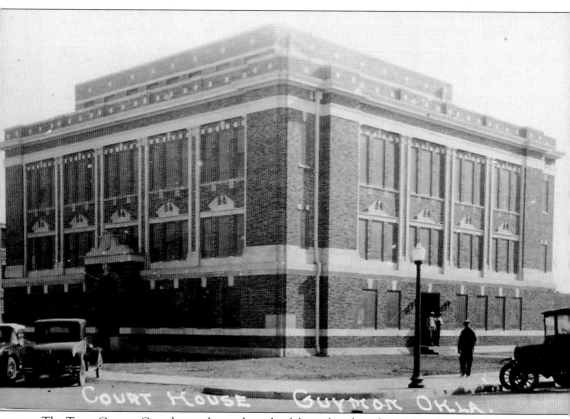

COURT HOUSE GUYMON OKLA.

The Texas County Courthouse, located north of the railroad track on Main Street, still looks as it does here in the late 1920s. According to its builders, the courthouse is so strong that it would last for a century—or centuries. Costing $200,000 to construct, it is four stories tall. The county jail occupies the fourth floor. It is the only courthouse in Oklahoma to be finished in mahogany. One of the features touted when it was constructed was its women's restroom. According to publicity, the facility would not have been outdone by any other ladies' room in western Oklahoma. Remarkably, such a large and splendid building was completed with no county indebtedness or bond issues. (Courtesy of Pioneer Showcase.)

Two

BUSINESS AND EDUCATION

Guymon's businesses have flourished and multiplied as the town is the only substantial location for shopping in the Panhandle. The town's very existence is owed to the fact that E.T. Guymon wished to leave Kansas and make his business fortune. Early businesses included John Blake's hardware store, Ed Summers's dry goods emporium, and the Jent and Ross livery stable. Even a plumber, D.Z. Stewart, from Salt Lake City, Utah, came specifically to install plumbing and septic systems in October 1910.

Guymon has been a go-to destination. Local industries like farming, ranching, oil, and pork production demand goods, services, and laborers that Guymon can provide. In the summer of 2013, Guymon boasted a 2.99 percent unemployment rate.

Main Street thrived from the 1940s to the 1960s. Among its many businesses were Oklahoma-based companies C.R. Anthony's, TG&Y, and OSTASCO. There were outlets selling ready-wear for men, women, and children; pharmacies; shoe stores; jewelry stores; and even a toy store. For a viable business life, a community must have fine schools to prepare future generations of entrepreneurs. Here again, Guymon succeeds. The school system started during the town's infancy, and as time progressed, children from outlying "country" schools were bussed to Guymon. This relocation of students put space and support demands on the community. Guymon stepped up to meet the challenge. The town has had many schools, including a Montessori school and a faith-based school for elementary grades. Guymon also tends to the needs of nontraditional and at-risk high school students with an alternative school. Known for strong programs in academics, speech and debate, music, and sports, Guymon schools have a proud legacy.

The majority of Guymon students do not speak English as a first language. Because of that, there is a definite correlation between Guymon's positive economic condition and its public education. This increase in immigrant numbers has impacted the town in terms of crime and health services, but the influx has allowed the tax base to increase, which has positively impacted the quality of business life and the educational system. Business and education are very connected—at least in the Oklahoma Panhandle.

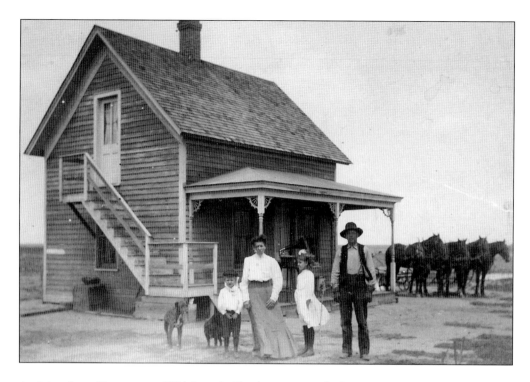

Arriving from Germany in 1884, Joseph Charles Byers worked in Chicago for Standard Oil for a year before sending for his wife, Pauline. In the 1890s, he transferred to Neodosha, Kansas. In 1900, Joseph and Pauline secured a homestead claim seven miles north of Guymon, and they became a typical frontier family and later a farming and ranching family. Above, the Byerses and two of their nine children, Annie and George, pose in front of the home. After five years, they built a larger house. In 1920, prosperity allowed them to build an even bigger home, one so nice that Pauline never wanted to cook in it. They eventually owned six quarters of land, an impressive farm-ranch business. As was customary, they had a big garden and a large orchard, farmed wheat, and raised horses, cattle, and mules. Below, Joseph and his son Edward (left) show off their roping prowess to some hired men. (Both, courtesy of Dana Tomlinson.)

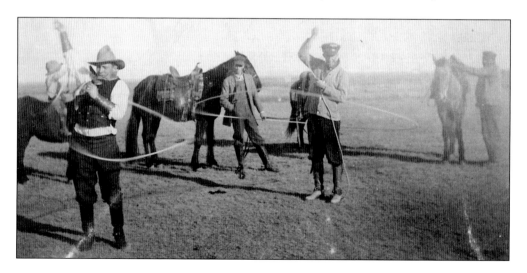

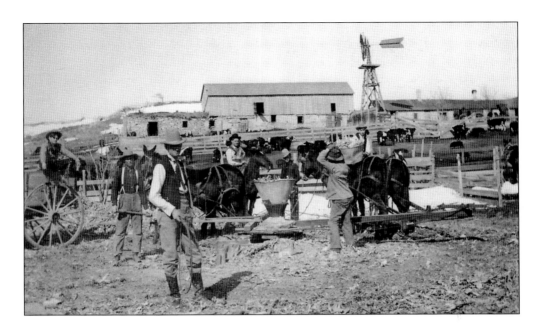

Cowboys did more than tend cattle. On a farm or a ranch, they had more responsibilities than simply bedding down the herd. The photograph above shows how cowboys made animal feed—with the brute force of men and animals. A man placed corn in the central hopper, and horses were connected to a grinder that ground the stalks as the horses circled. The finished product was deposited in the trough seen at right. In the photograph below, cowboys dip cattle. In order to prevent external parasite infestations, cows—and at times other creatures—were run through a dipping station. The animal was forcibly immersed into the solution and came out dripping but protected from biting insects that bedeviled the cattle and spread disease. Such a process is illegal today. (Above, courtesy of Lobit Studio; below, Guymon Public Library and Arts Center.)

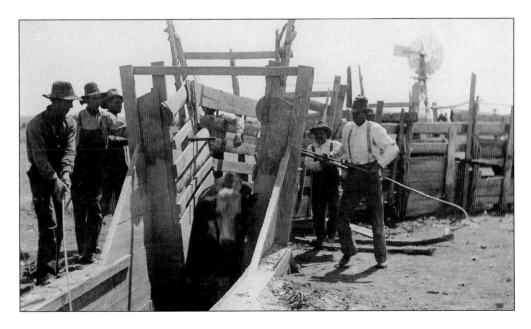

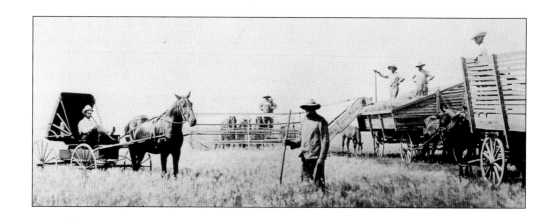

Panhandle farmers found that the soil was conducive to growing grains, especially wheat and later corn, sorghum, and even cotton. Early-day wheat harvest crews, like those shown in these photographs, tackled wheat fields using mules for pulling power. The wheat would be cut and then threshed with an archaic implement known as a threshing machine, which separated the wheat kernels from the stalk and chaff. The photograph above was taken in the Ivan Perkins wheat fields in the summer of 1910. (Above, courtesy of Lobit Studio; below, Guymon Public Library and Arts Center.)

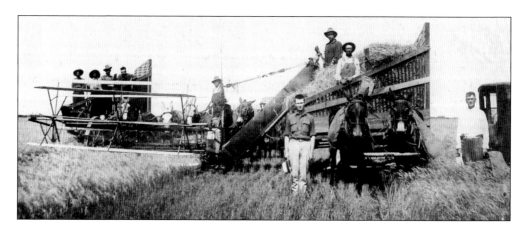

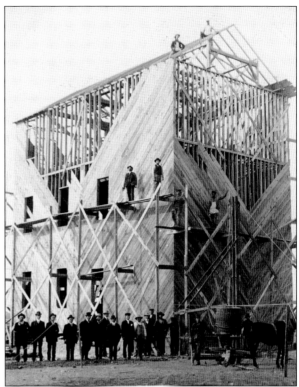

After wheat was harvested from Panhandle farmers' fields, it could be made into flour; therefore, Guymon constructed its own flour mill. Note the crisscross construction of the interior walls' boards and the structure's height. It certainly was not easy to erect this multistory building, used by many local farmers. The photograph at right was taken on Oklahoma statehood day, November 16, 1907. The completed building is seen below in 1908. (At right, courtesy of Pioneer Showcase; below, Lobit Studio.)

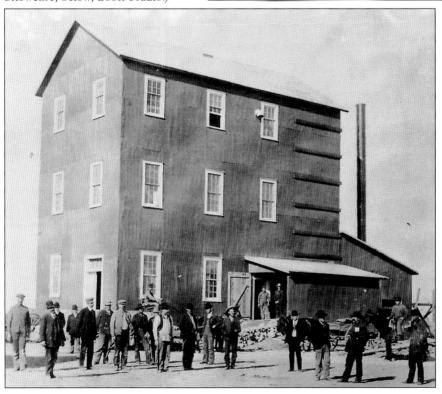

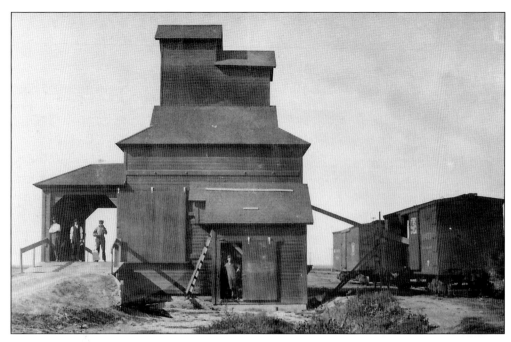

Guymon came into being primarily in the interests of economic profit. An important aspect of Guymon's commerce stemmed from farming in the region. Farmers needed a place to store their grain that was near the railroad tracks so that the grain might then be transferred from the elevator to grain cars, which would then take the product to distant mills. Guymon had many elevators as these photographs attest. The photograph above shows Guymon's first grain elevator, built in 1908. (Above, courtesy of Pioneer Showcase; below, Lobit Studio.)

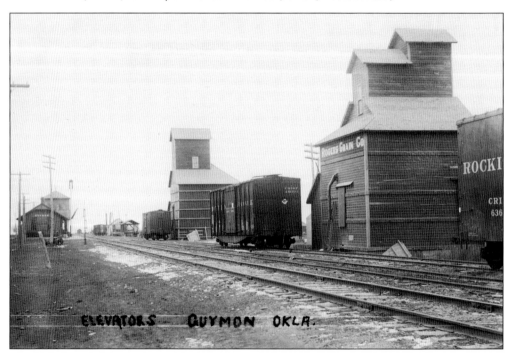

This 1940s photograph captures a long line of Panhandle wheat farmers trucking their grain to the Phillips elevator in Guymon. Such a scene is still witnessed each summer when wheat trucks cart their golden cargo from fields to elevators where farmers sell their harvest, hoping for the best price of course. Rural communities by and large support grain elevators as much space is needed to accommodate all of the rich harvests that the Panhandle provides America and the world. (Courtesy of Duane and Sandra Fronterhouse.)

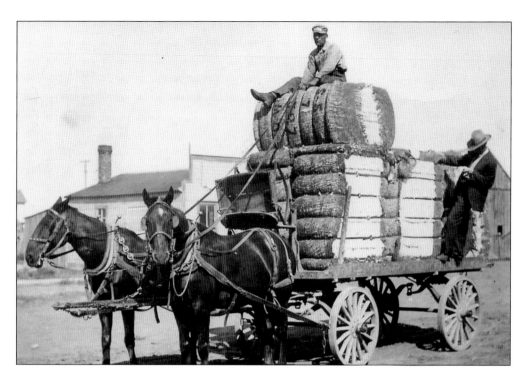

The photograph above shows the very first cotton bales to arrive in Guymon in 1911. Shown below are some broom corn bales in 1909. Cotton and broom corn were profitable commodities in the early 1900s; however, the Dust Bowl's drought years ended that. Recently, cotton has made a resurgence in the Panhandle, and farmers have once again started to plant the crop. Farmers mainly utilize the nearest cotton gin, Moore County Gin in Dumas, Texas. These days, gin employees come to the field to pick up bales for processing. (Both, courtesy of Lobit Studio.)

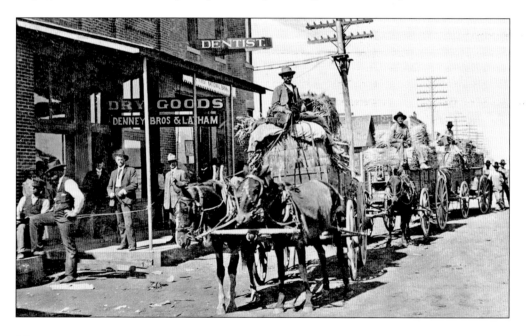

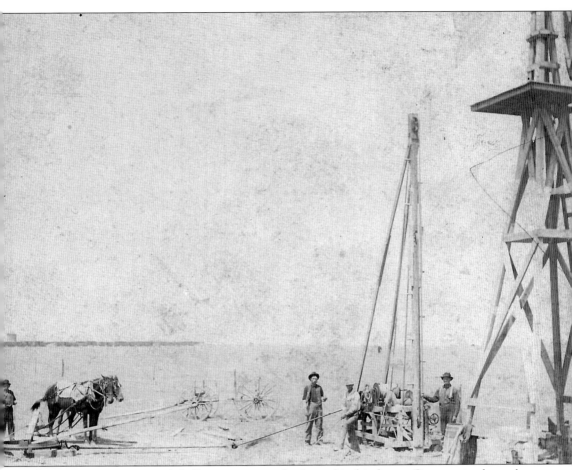

This is a very primitive oil-drilling operation, the first of its kind near Guymon in the early days of the 20th century. No hydraulics pumped the oil from the bowels of the earth; instead, horsepower and manpower performed the task. Gone are the days of such rudimentary technology in what has become one of the Panhandle's mainstays of economic development: the oil and gas industry. Oil found near Guymon is part of the vast Hugoton Field, discovered near Liberal, Kansas, in 1922. The southern end of the field rests in the center of Texas County, Oklahoma. This repository of oil and gas reserves is the biggest in the United States and the second largest in the world. (Courtesy of Guymon Public Library and Arts Center.)

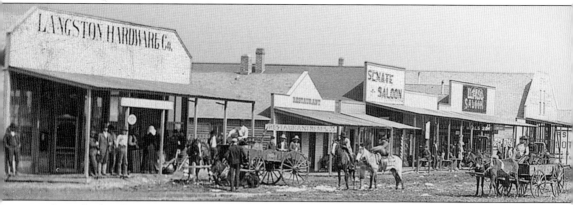

In early-day Guymon, many saloons were established around the railroad depot. This type of business was not unusual for towns. History records that the first saloon—actually, the first business in town—was operated by an old ex-cowboy named Jimmy McQuillan, who, according to contemporaries, was not a good businessman, for he drank up the profits. A snazzier drinking establishment was the Senate Saloon, which had been dragged on a skid by horses 20 miles from Hardesty. The owner thought that Hardesty would cease to exist when the railroad decided to bypass the town. At the Senate, he sold patrons tokens with which to buy their refreshments. He did not care if customers used their tokens or not, for he already had their money. Guymon's saloons closed when Oklahoma became a state in 1907 and liquor was outlawed. (Courtesy of Pioneer Showcase.)

A perennial symbol of Guymon is the redbrick First National Bank building and its cupola. The nationally chartered bank opened its doors on March 17, 1906, with the financial support of several men, including J.H. Wright and some rancher friends from east of Guymon. Wright became the institution's first president. Originally, the bank shared its space with the telephone company and the dental office of a Dr. Lightner. The photograph at right was taken in the 1950s. The bank building formerly had a 15-foot mast on top, visible in the 1911 photograph seen below. The flagpole served a purpose. Each day from 1906 until 1917, the weather forecast, received by telegram from Shreveport, Louisiana, was broadcast to residents via colored flags indicating clear, cloudy, or wet weather. (Both, courtesy of Lobit Studio.)

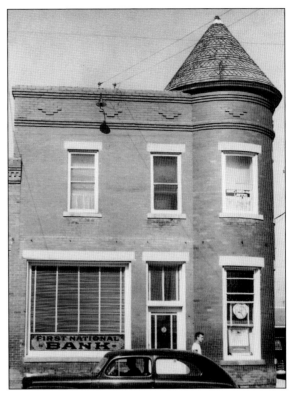

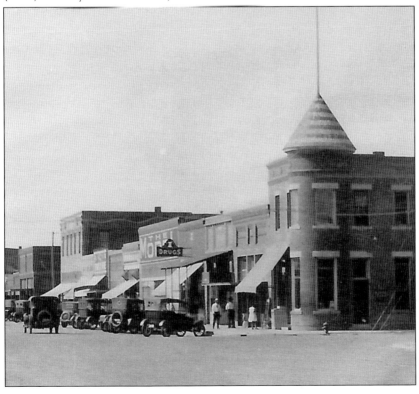

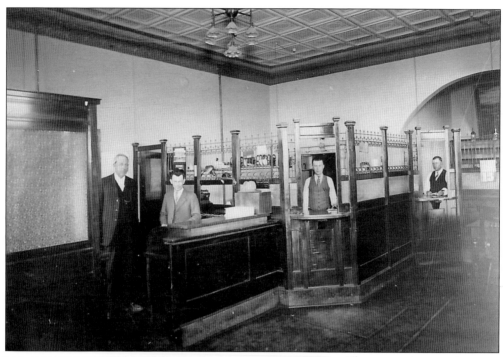

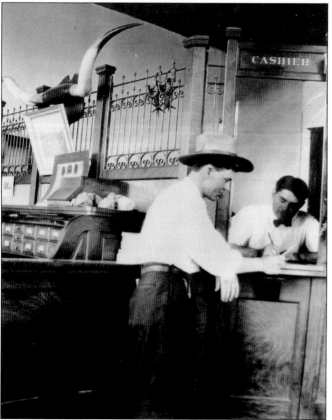

These two photographs show the interior of the First National Bank, including the tellers' line. At left, note the decidedly masculine Western decor: cattle horns and a pair of spurs casually hung on the wrought-iron grating. The building still stands, but the cupola has been gone for some time now. Current city offices will relocate to this building after it is remodeled—making that which was old fresh and new again. Guymon is never far away from its past, and it makes the best use of all of its resources. (Both, courtesy of Lobit Studio.)

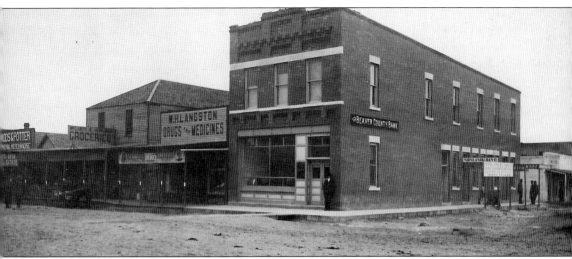

Known as the Star Banking Company when it began in July 1901, the institution changed its name to Beaver County Bank in August 1901 when E.T. Guymon and George Ellison, Guymon's uncle, and three other gentlemen put up $10,000 for stock. The bank opened its doors for business on October 1, 1901. At the close of that day's business, it had acquired $330.85 in deposits. In 1911, the bank became City National Bank and Trust, still a local banking institution. (Courtesy of Guymon Public Library Arts Center and Pioneer Showcase.)

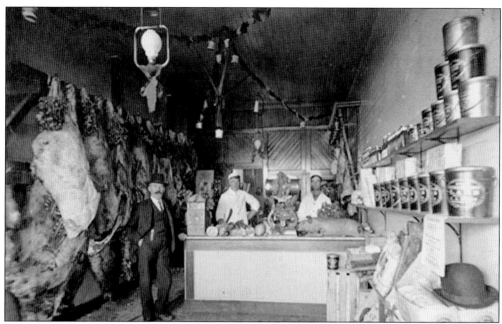

The above photograph shows the City Meat Market, owned by C.A. Booth, in 1906. Posing inside the store are Booth (left), Henry Holzchuz (center), and Howard Booth. The store sold fresh and cured meats and processed and butchered animals. The Elite Café, below, was also owned by C.A. Booth. New types of businesses blossomed in the early 20th century as individuals were less apt to do butchering or food preparation or other ordinary things that pioneers had done, such as making clothing, planting gardens, and canning vegetables. People came to rely on others to do those things for them. The world of business changed to a commercial exchange of goods, services, and cash. Hence, restaurants, ready-made clothing stores, and grocery stores began to proliferate. (Both, courtesy of Pioneer Showcase.)

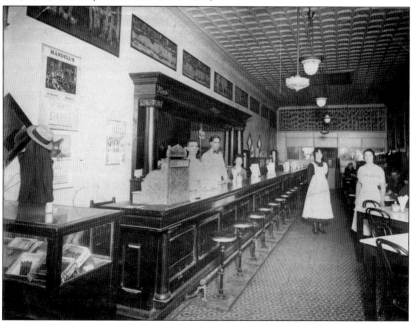

Bill Wanser and D.G. Hamilton opened a drugstore, often referred to by locals as "The Post Office Drug Store," because residents could sometimes pick up mail there. Initially, the store sold everything from house paint to horse liniment and candy to medicine. In the 1910s, it moved north on Main Street and offered "newfangled items" like a soda fountain and ice cream. A ready-made drink known as Hostetter's Bitters sold well, primarily because it contained 12 percent alcohol. The store opened, even on Saturdays, at 6:00 a.m. and curried a large clientele. The photograph below, showing the flashy, shiny, tin-lined interior, was taken in the 1920s. (Above, courtesy of Lobit Studio; below, Guymon Public Library Arts Center and Pioneer Showcase.)

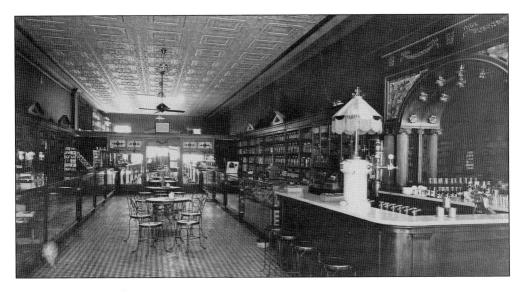

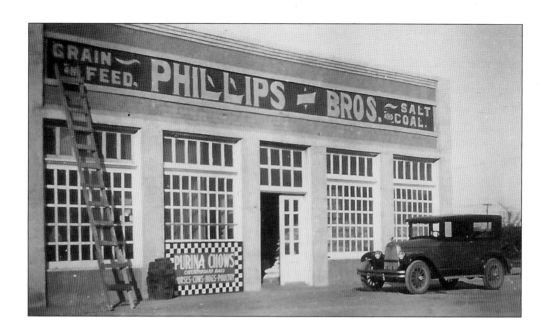

What would a rural community be without a feed store? Guymon has had many feed, grain, and farm stores. Farmers, ranchers, and town residents shopped at these establishments, for everyone needed garden and canning supplies, eggs, chickens, milk, and commodities. Farmers, especially during the Depression, traded foodstuffs for items sold by the feed store. Feed and grain dealers always offered a great incentive, delivering in town and in the countryside. An early feed store belonged to C.W. Claycomb. Other such businesses were owned by the Phillips Brothers and by Tot and Earl Smith, who operated through World War II. Until the 1970s, the Smiths' store was the largest Pioneer brand corn and grain sorghum dealer in the United States. The Tyler Feed Store is seen below in the early 1950s. (Both, courtesy of Duane and Sandra Fronterhouse.)

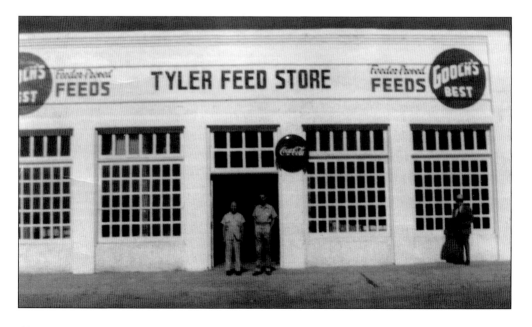

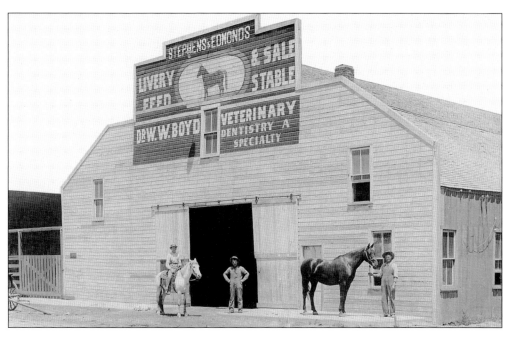

In the early 1910s, when the newfangled transportation method—the automobile—became popular, many mechanics opened garages. These establishments initially tended to horses, buggies, and wagons as well as automobiles. One could stable his team and repair his automobile at the same place. The livery stable above looks like it could handle just about anything with four legs or four wheels. Because of the large number of automobiles in town in 1929, the Guymon newspaper launched a campaign to bring the town "out of the mud" of its streets, advocating that all streets, not just Main, be paved. Automobile dealers included Ennis and Dale, who sold Buicks; Blake's sold the Chevrolet brand; Langston and Lyons sold Maxwells; and Carmon Nall sold Fords. In early 1918, a new Ford cost $506. (Both, courtesy of Pioneer Showcase.)

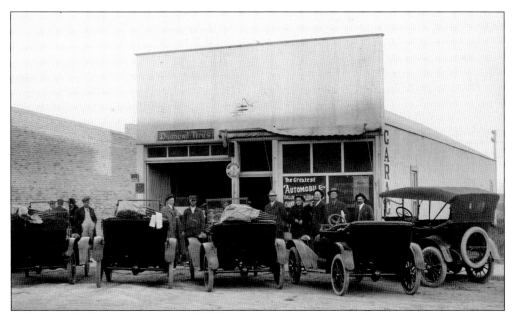

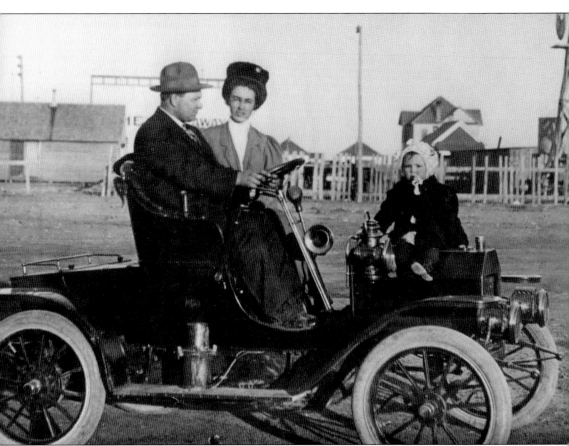

Among the earliest residents and entrepreneurs of Guymon, Clem and Lelia May Funk sit in their car, a 1908 REO Speedwagon, on Main Street heading south. Their son Nelson sits on the hood. Clem Funk put an advertisement in a Jennings, Louisiana, newspaper for a housemaid, and Lelia responded. The two soon married. Lelia and May Streets, named for Mrs. Funk, divided lots sold by Mr. Funk at his realty company. (Courtesy of Mike and Joann Holland.)

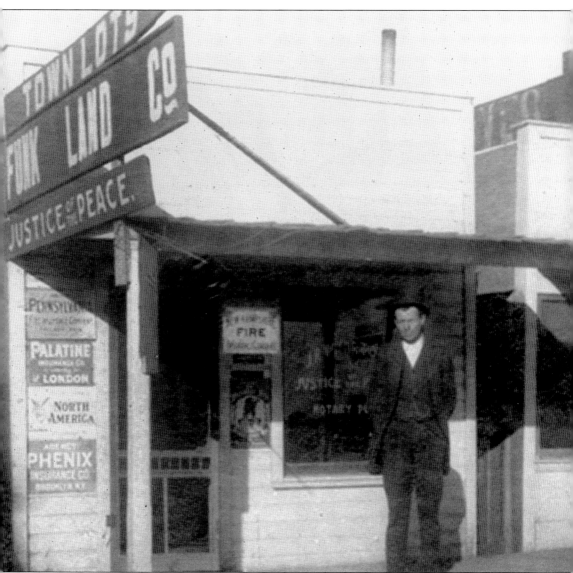

The Funk Land Company, owned by Clem Funk, was an early realty company in the 1910s. Originally from Jennings, Louisiana, Clem and his father heard about the railroad pushing westward through Guymon and believed that they could make a good business by selling land to early settlers. The elder Funk financially helped Clem purchase land in Guymon upon which to speculate. The man in the photograph, lawyer and justice of the peace J.R. Wharton, stands in front of the Funk office. (Courtesy of Mike and Joann Holland and Guymon Public Library and Arts Center.)

Born in Massachusetts in 1859, Stanley C. Tyler attended Harvard, decided to come west, and arrived in the Texas Panhandle in 1879. He married Mary, his Massachusetts sweetheart, and started their V-Z Bar Ranch. Their wedding photograph is shown above. Upon retirement, they moved to Guymon in 1907 and decided to help the fledging community thrive. Tyler established the town's first power and water plant. He also developed its first telephone company by stringing wire from his country house to the First National Bank, where he served as president. The Tyler home, built in 1907, is still inhabited by 21st-century ancestors, Louis and Sandy Latham. (Above, courtesy of Joyce Smith; below, Leonene and Carroll Gribble.)

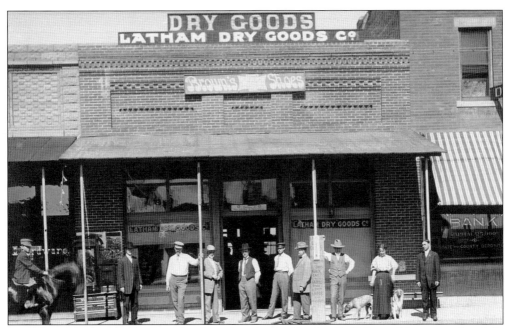

In addition to their banking and utilities businesses, Stanley C. Tyler and his son-in-law L.E. Latham owned and operated a dry goods emporium, Latham Dry Goods. In the photograph above, Stanley and Mary Tyler and their hunting hounds are seen at right. The photograph below depicts the store's interior. Note the plethora of items for sale and the way they are displayed. The Tylers were Episcopal, but Guymon had no such established denomination, so they went to church with the Presbyterians. Stanley Tyler died in 1927, and Mary died nine years later. (Both, courtesy of Pioneer Showcase.)

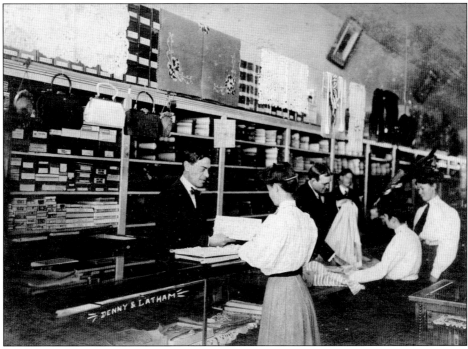

Born in Indiana in October 1877, Rutherford Burchard Hayes arrived in Guymon in 1906 and started his medical practice in a room behind a pharmacy. He had met the druggist in medical school. When the druggist relocated to Guymon to begin his business, he invited Hayes to join the community, which needed a good doctor. Over the next 50 years, Hayes became a beloved figure as the quintessential country doctor. There was no call too distant or weather too inclement to keep Hayes from visiting the sick. (Courtesy of Pioneer Showcase.)

Through the years, the McMurry family has practiced medicine in Guymon. This is an image of William Dwight McMurry. The McMurry clinic served as the local hospital in the 1940s and 1950s, and many Panhandle residents were born there. Continuing the tradition, Dr. R. Kelly McMurry, a general practitioner fondly known as "Doctor Kelly," has his own McMurry Clinic. His daughter Kelsey represents the third generation of McMurrys in medicine, for she currently studies nursing at Oklahoma Panhandle State University. (Courtesy of R. Kelly McMurry.)

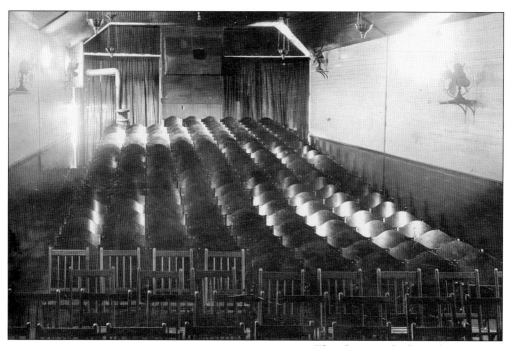

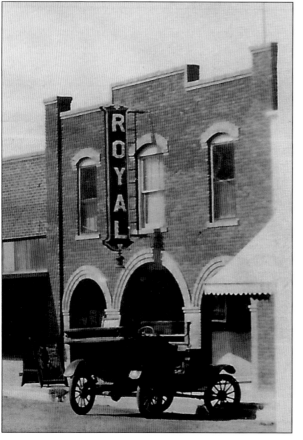

The photograph above depicts the interior of Guymon's Dime Theater, originally known as the Nickelodeon. It housed a stage on which vaudeville acts performed. During its time as the Dime Theater, owners installed a screen to show movies, with Saturday-night Westerns being the most popular. Eventually, the name and facade changed to the Royal Theater, seen at left. In the 1960s, it became the American Theater and was built around massive film-projection equipment. Today, the refurbished American Theater houses Guymon Community Theatre productions. (Above, courtesy of Pioneer Showcase; at left, Lobit Studio.)

Arriving in 1908, Anders L. Mordt and his family planned to establish an immigrant Norwegian farming community, Oslo, just south of Guymon in Texas, via the Anders L. Mordt Land Company: Norwegian Colonization and Immigration in and to the Great Southwest. In addition, he operated the only foreign-language newspaper in Oklahoma at the time. This photograph shows Mordt's office and a group of prospective land buyers on the way from Guymon to see the Oslo farmland. By 1913, Mordt had given up his plans for a Norwegian colony and moved to Chicago. The Mordt family built the home known as Danholt (see page 46). (Courtesy of Pioneer Showcase.)

This 1930s photograph shows Con Gilliland in his Main Street barbershop that he operated for over 50 years. Gilliland (far right) poses with employees Amos Bartels (second from right), Mr. Shackleford (seated), Johnny Gilliland, and shoe-shine boy Jack Hankla (seated against the back wall). In 1903, Gilliland came to Guymon at age seven with his family in a covered wagon from Texas; they lived in a dugout three miles east of town. (Courtesy of Lauretta and Bill Garrison.)

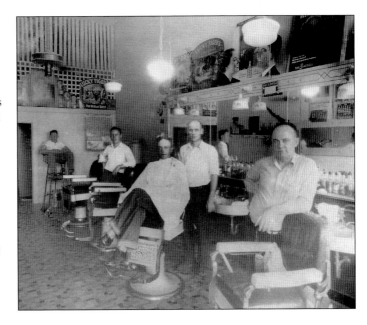

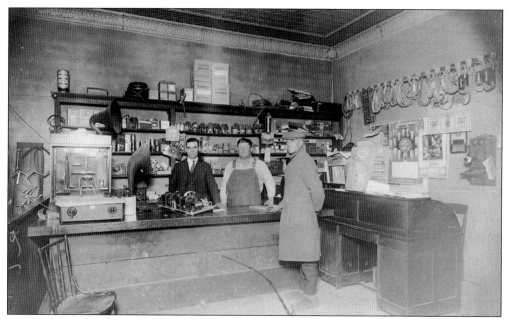

Walden Battery and Electric Company, one of the significant businesses in town, began in the 1920s. It sold most everything dealing with electrical needs, including lightbulbs, batteries, Victrolas, and radios. The 1920s saw Texas County Gas Company bury lines for public access, so Guymon residents had the choice of electric or gas power for cooking, heating, and light. The days of heating and cooking using coal and cow chips had ended. (Courtesy of Pioneer Showcase.)

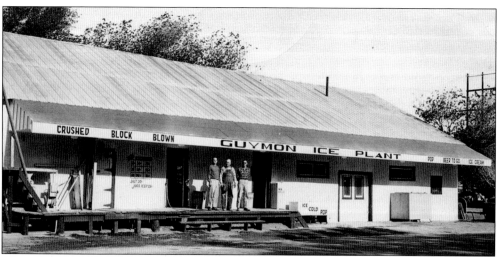

Glenn Critchfield and W.F. Klein owned and operated the Guymon Ice Plant beginning in 1927. That year had an extremely cool summer, so they did not sell much ice. Most summers, however, the plant operated on a pair of 12-hour shifts each day. People could order ice delivered, or they could pick it up themselves. The plant remained in operation until the late 1940s when refrigeration made ice blocks a memory. (Courtesy of Pioneer Showcase.)

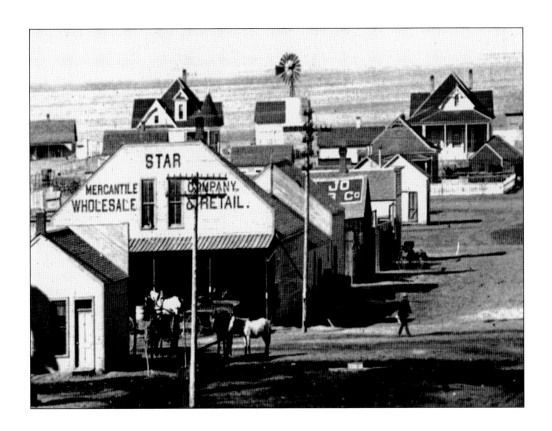

The original lumberyard in Guymon opened in 1900 as Star Lumber Company with E.T. Guymon at the helm. The photograph above features the original structure, only 576 square feet. It burned down in the 1920s. E.T. Guymon rebuilt and eventually sold the business to another man who developed Youtsler Lumber. In 1967, Mack Wirtz bought the building, and today, Wirtz Lumber (below) carries on the tradition of providing home goods and construction needs to Guymon and the surrounding area. The company has grown through the years and encompasses a 12,000-square-foot showroom and an entire block of lumber storage. (Above, courtesy of Pioneer Showcase; below, author's collection.)

The Hispanic influence is great in Guymon. Most Spanish-speaking immigrants come from Mexico, but some hail from Guatemala, Honduras, and other Central American countries. Since the early 1990s, immigrants have come to work in area meatpacking companies, including Seaboard Foods in Guymon; National Beef in Liberal, Kansas; and JBS in Cactus, Texas. Some have opened clothing stores, mechanic shops, and restaurants, boosting Guymon's economy and creating a diverse and colorful Main Street. Because of the influx of immigrants, Texas County's population increased five percent between 2000 and 2010. Texas County is the only Panhandle county to gain population during that time. (Author's collection.)

A vital Panhandle enterprise is the Hitch Ranch and all of its associated businesses. James K. Hitch ran his first cattle herd, branded with OX, in the mid-1880s in No Man's Land. Since then, Hitch family members have created a multimillion-dollar agricultural company comprised of cattle feeding, hog production, farming, feeder cattle, and a commercial cow herd. Hitch is one of the most influential agricultural corporations in the five-state area as well as Oklahoma. Of course, the enterprise employs many Guymon residents. As a generous community sponsor, Hitch Industries contributes a great deal of time, finances, and labor to help make local events possible. (Courtesy of Tito Aznar.)

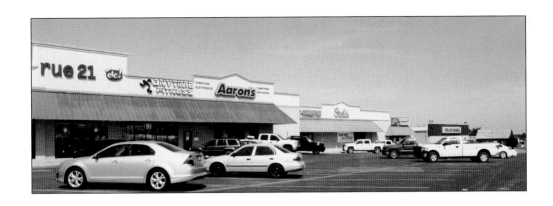

Guymon residents shop at many stores. At the Mariah Strip Mall (above), Northridge Plaza (below), downtown, and Wal-Mart, Guymonites can find nearly anything: clothing, footwear, accessories, gifts, housewares, appliances, fitness plans, legal offices, accountants, karate instruction, thrift stores, automotive parts, formal wear, framing, tattooing, and groceries. No small town, including Guymon, would be complete without John Deere, GM, Ford, Tractor Supply, lumberyards, garden centers, hardware stores, barbers, and hair and nail salons. A new grocery store, Carter's Country Grocery, recently opened in Northridge Plaza. (Both, courtesy of Tito Aznar.)

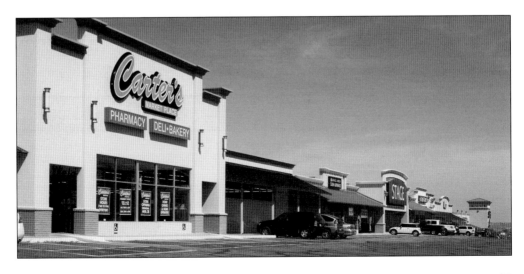

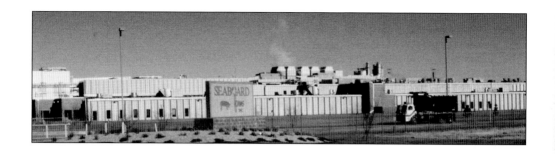

Seaboard Foods of Seaboard Corporation, the nation's second-largest pork producer, maintains a plant in Guymon (above). It is supported by Seaboard Foods Live Production facilities for breeding, farrowing, nursing, and finishing hogs. Established in 1995, Seaboard employs over 2,600 people who bring hogs from the barn to the grocery store. This plant is one of the nation's two largest pork facilities. Over 100 truckloads of live animals are slaughtered daily, and nearly 100 trucks take processed meat from the plant daily. Seaboard operates a feed mill plant north of Guymon, and its High Plains Bioenergy plant (below) uses pork renderings to create biodiesel for company trucks. (Above, author's collection; below, Seaboard Foods.)

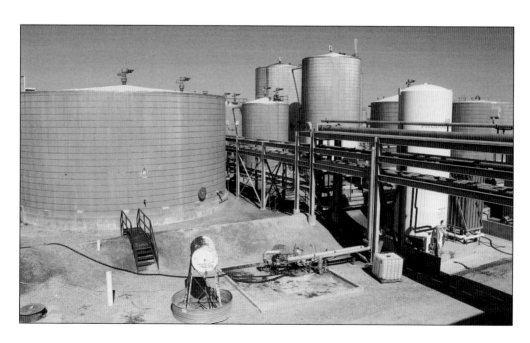

In 2006, Oklahoma Panhandle State University in Goodwell opened a Guymon classroom to offer college courses in a convenient location for those interested in taking limited hours each semester. Besides English and history courses, specialty classes are often available, such as Panhandle archeology, firefighting, and emergency medical technician training. It sometimes serves as a gathering spot for after-hours business receptions for the campus and community. Consuelo McFadden (left) is the classroom coordinator. (Author's collection.)

Wild Horse Art Gallery showcases local artists' talents and provides teaching opportunities for Goodwell's Oklahoma Panhandle State University art majors. Students learn to develop and manage gallery space and aspects of the art business. Among photographs, jewelry, paintings, and pottery, higher education meets the real world, strengthening students' educations. It also hosts after-hours meetings and is a great place to meet new people, explore art, and start conversations about community and the humanities. (Author's collection.)

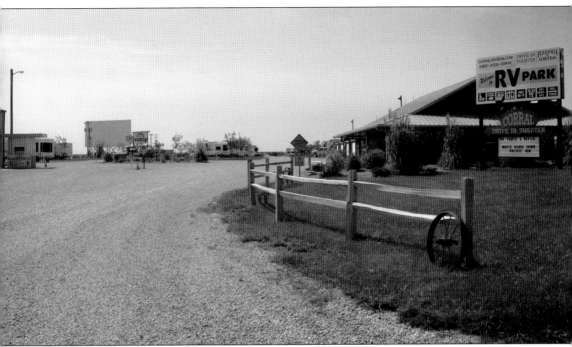

Panhandle highways, especially US Highway 64, ferry many "snowbirds," retirees who travel from their permanent homes in Northern states to a warmer climate, like Arizona or Southern California, for the winter. Many pull their "home away from home" with them as did the pioneers and traders who traversed the region over 100 years ago. To accommodate these travelers, two RV parks are located on the southwest side of Guymon; one even has a drive-in movie theater. (Courtesy of Tito Aznar.)

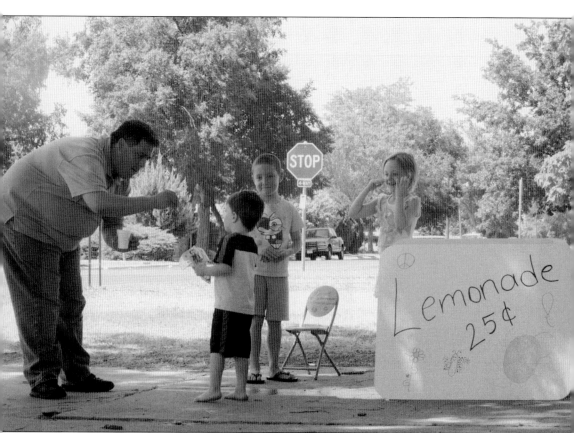

Guymon businesspeople start their careers early in life—just like Presley Evans (right) with her lemonade stand in July 2013. It looks like her enterprise is a hit with the neighbors. Pastor Steven Lehew (left), Gavin Evans (second from left), and Kayden Lehew (third from left) all seek to slake their thirst at the same time. Guymon prides itself on business incubation, and the chamber of commerce takes an active role in helping local businesses become reality. (Courtesy of Jessica Crawford.)

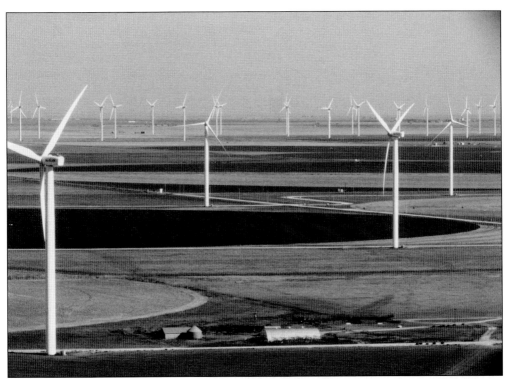

Novus Windpower, LLC believes that the "Texas-Oklahoma Panhandle is ideal for capturing excellent wind resources." As a result, the California-based company established Great Plains Windpower, LLC in Guymon. For 11 years, the company has developed wind-generated energy facilities south of town. The initial installation included towers in two locations. Construction and maintenance of the towers and the transfer of the electrical power have positively impacted the community by bringing jobs, stimulating the economy, and impacting housing, health, and schools. Shown above is a typical field of wind towers. The photograph at right shows the lifting of the nacelle, which contains all of the generating components that make the wind turbine work. Helicopters or enormous cranes hoist the nacelles into place atop the towers. (Both, courtesy of Randy Lobit.)

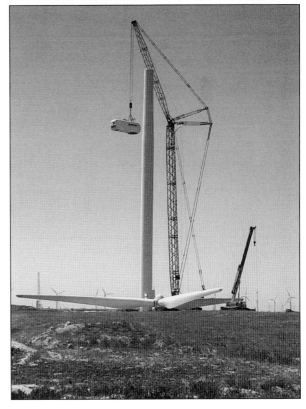

A master photographer, Edgar Lobit arrived in Guymon in 1958 and with his wife, Marjie, opened a photography studio, emphasizing portraiture. He served as president of the American Society of Photographers and the Rocky Mountain Professional Photographers Association. He participated in the first American cultural photographic exchange with China and toured Russia and Vietnam with the same program. Lobit won three national awards for his services to the Professional Photographers of America, doing it all from his in-home studio in Guymon. (Courtesy of Lobit Studio.)

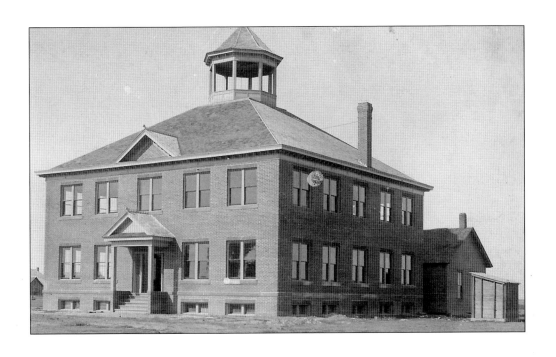

Guymon's first school for upper grades came in 1907, when the two-story brick building seen above housed upperclassmen on the second floor. George T. Payne served as superintendent at the time. Below, the school's playground is being put to good use by young students. (Both, courtesy of Guymon Public Library and Arts Center.)

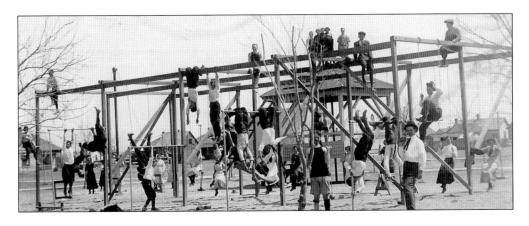

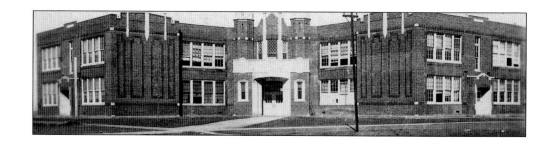

Between 1907 and 1916, Guymon supported two country schoolhouses, about five miles east and about five miles west of town. In 1916, they closed, and students were bussed to Guymon. To accommodate the increased number of students, a high school (above) was built in 1916. A junior high school was erected in 1929, but it burned down in 1943. Additional schools have been constructed during the last 100 years and currently number nine: a high school, a junior high school (its unique interior features shown below), and seven elementary schools, including the newest, Prairie View, which rests west outside of town. (Above, courtesy of Guymon Public Library and Arts Center; below, Tito Aznar.)

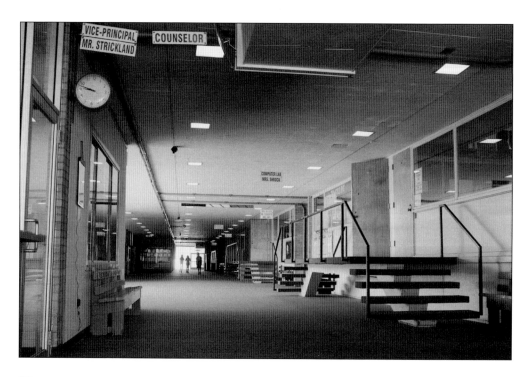

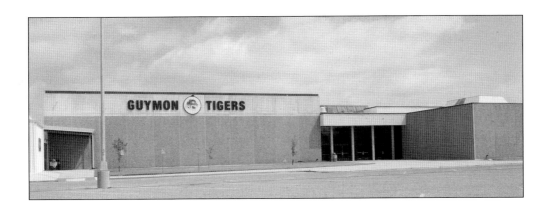

The sole Guymon high school, shown above, sits on the northwest side of town. The campus includes a baseball field, an agricultural education building, and a greenhouse. A new addition was constructed in the early 2010s. The photograph below shows Guymon's private Christian elementary school, Northridge School. It is located across the street to the south of the high school. In addition to these schools, there is an alternative school for nontraditional, working, and at-risk students. Here, students learn via pedagogical techniques suited to their individual learning styles and aimed at keeping them in the classroom and on the road to graduation. (Both, author's collection.)

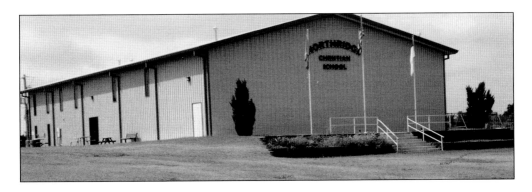

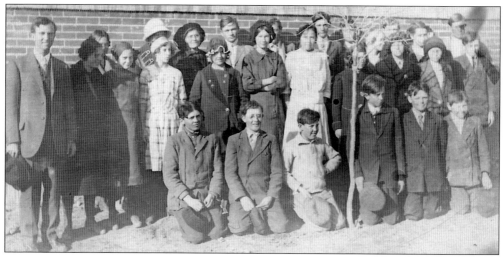

Newton Ballenger (in the suit at far left) homesteaded in the Panhandle in 1905. He taught in Texhoma, about 20 miles southwest from Guymon, from 1909 until 1915. He then moved to Guymon, becoming the community's grade-school principal. He is seen here with his 1915 class. Students called him Professor Ballenger. His wife, Doris, also taught in Guymon. After retiring from education, he worked as a rural mail carrier for the Guymon Post Office. He died in 1958. (Courtesy of Guymon Public Library and Arts Center.)

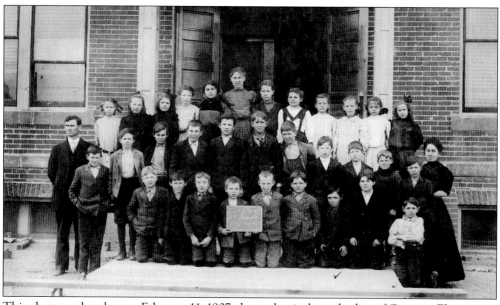

This photograph, taken on February 11, 1907, shows the sixth-grade class of Guymon Elementary School. The teacher on the far right is Miss Lloyd, and the Guymon superintendent, W.H. "Will" Grimm, stands on the far left. Guymon schools have progressed much since the turn of the 20th century. The first school building in town, constructed on Block 22 in 1904, had two rooms separated by a hallway that served as storage. By 1907, the building was relocated and used until it burned down on January 1, 1911. (Courtesy of Bill and Lauretta Garrison.)

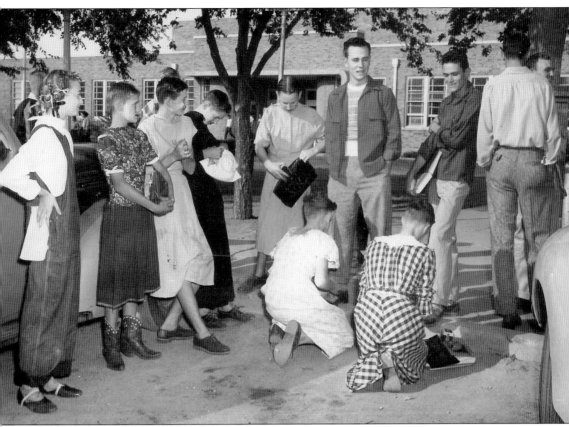

In the 1950s, students in public schools typically initiated freshmen. This 1950 photograph shows freshmen boys dressed as girls bowing to their superiors—seniors—outside Guymon High. Note the girl on the left dressed as a boy. As well as dressing in the garb of the opposite gender, on this day, freshmen wore clothing inside out and backwards. Frosh initiation culminated on the first Friday of the first week of class during the fall semester. In the auditorium, seniors continued their good-natured "torture" by having freshmen push peanuts up a ramp with their noses or sing the school song with full mouths. After enduring the ordeal, freshmen became full-fledged Guymon Tigers. (Courtesy of Leonene and Carroll Gribble.)

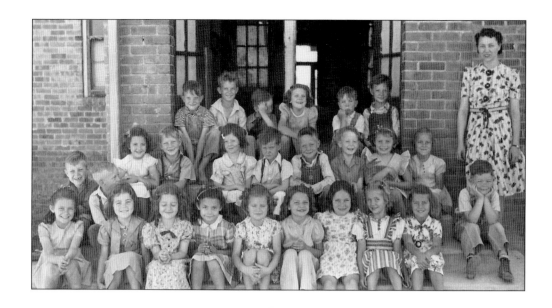

In the photograph above, a smiling group of first graders and their teacher, Ruth Wheelock (far right), pose in front of their school in 1940. Below, the same students, all grown up, pose in their academic regalia as Guymon seniors 12 years later. In the earlier photograph, Mary Leonene Valdez Gribble is in the first row, fourth from left; she stands fourth from the left in the first row in the later photograph. Gribble taught reading and liberal arts classes in the Guymon public schools for 21 years, retiring in 1989. (Both, courtesy of Leonene and Carroll Gribble.)

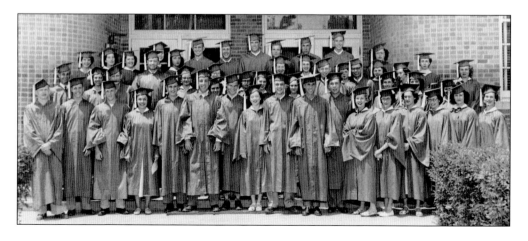

Three

ACTIVITIES AND EVENTS

Typically, people who are not from the region will ask Panhandle residents, "What do you do out there?" The answer is a lot actually. Granted, the Panhandle has no fine-dining establishments, shopping malls, performance venues, big stadiums, or chain companies. As a result, people must create their own excitement, action, and fun.

Guymon has taken the lead on such creativity and finds encouragement in its past. Years ago, residents found any excuse to get together to talk, eat, and share information at frontier events like barn raisings, cowboy reunions, quilting parties, box suppers, Fourth of July celebrations, weddings, and business openings. That really has not changed much through the years. Any reason to come together as a community is a good thing. The premier event is Pioneer Days each May, celebrating the Panhandle's pioneer and frontier heritage. Everyone in the area, even folks from out of state, comes to participate. Guymon sponsors many community-wide events: the Pumpkin Patch Crafts Festival, the Flatlanders Car Show, the Sunflower Art and Wine Festival, Ranch Cowgirls Rodeo Association events, Oktoberfest, and the Christmas parade. In addition, the Guymon Community Theatre mounts several dramatic, comedic, and musical productions each year.

Because of the relative isolation of the Panhandle, citizens have always sought entertainment. One simple solution to that problem is engaging in sports. Of course, Guymon schools provide plenty of athletic events. Local citizens somewhat older than school-aged have gotten into the action as well with rodeo, demolition derbies, golf, and running. Another way to find fun is to celebrate culture, and Guymon does that well. Hispanic and African cultures are featured at the Fiesta and the Azuma festivals. Playing a large role in Guymon's cultural life, the Main Street Office cooperates with city government, state tourism, and the Oklahoma State Historical Preservation Office to coordinate, develop, and mount activities that promote Guymon, the Panhandle, and cultural icons of the region: cowboy, oilman, burrito, livestock, cholla, wind, and tumbleweed.

Guymon knows its history and takes pride and enjoyment in finding ways to celebrate and revere its heritage for future generations. Guymonites know how to party, and they find excuses to come together to enjoy a down-home celebration.

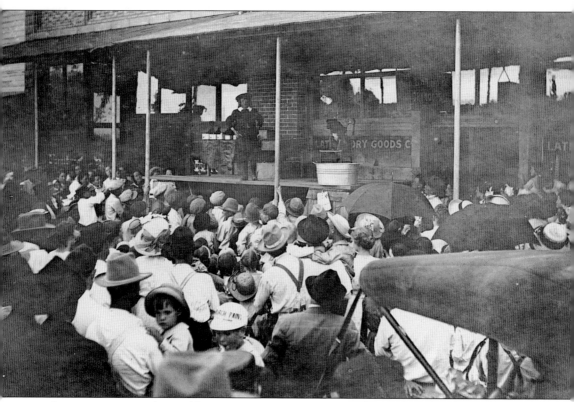

In years past, people would use any reason to come out, bring their families, enjoy a new experience, and fraternize. This 1910s visit from shoe ambassador Buster Brown was just such an occasion. Appearing live and in person on the porch outside of Latham's Dry Goods Store, Buster Brown drew a large crowd on a warm summer afternoon on Guymon's Main Street. (Courtesy of Pioneer Showcase.)

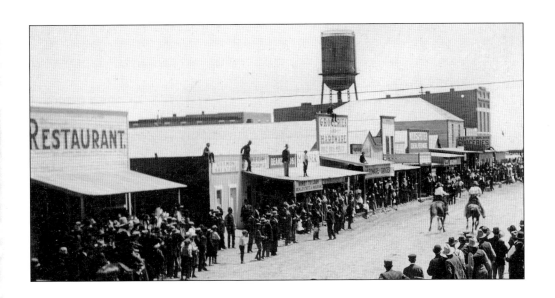

Among the popular activities enjoyed by Guymonites was horse racing as illustrated in these photographs. The race shown above took place on Main Street. It must have been an important contest as people jockey for a good look of the proceedings from the tops of buildings. Horse racing also occurred west of town, even before Guymon had a "main street," as the turn-of-the-century free-for-all race shown below attests. (Above, courtesy of Pioneer Showcase; below, No Man's Land Museum.)

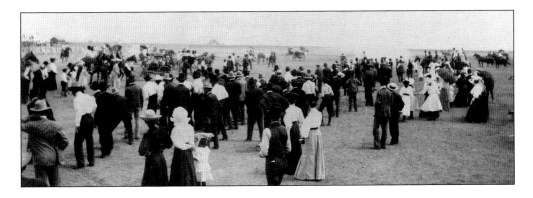

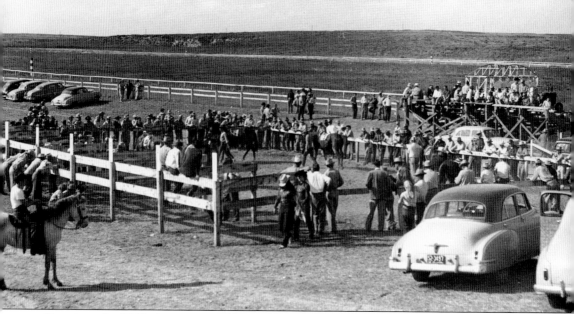

Even into the 1940s, horsemen and horsewomen raced at the location that eventually became the Hitch Arena on the west side of town. This horse-racing area provided spectators with places to watch the excitement. Longtime Guymon resident Imogene Glover remembers that when she was in her prime, in the late 1940s, she would ride horses in these races because she was light and agile and a fine horsewoman. Most anything dealing with horses still draws a crowd in the Panhandle. (Courtesy of Pioneer Showcase.)

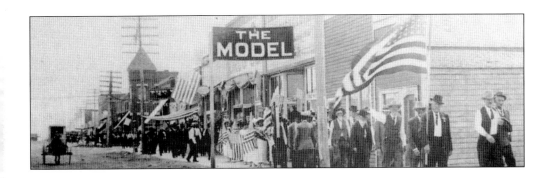

To honor the 50th anniversary of the Civil War's Battle of Gettysburg and the men who fought and died there, Guymon veterans and patriots marched along Main Street. The photograph above was taken on May 30, 1913. Other patriotic celebrations occurred as well, like Fourth of July parades, which were always popular events. The photograph below captures a July 4, 1903, parade. War veterans and old cowboys always sought a reason to come together and relive old times. (Above, courtesy of Lobit Studio; below, Bill and Lauretta Garrison and Diane Roberts.)

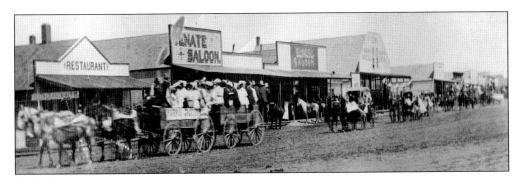

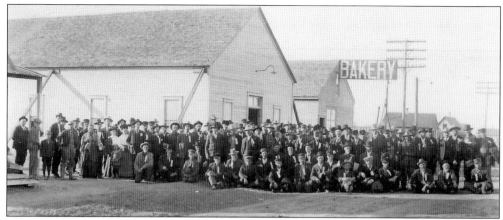

It has always been important for Panhandle citizens to express their political ideas. This 1909 photograph captures local stockmen and farmers meeting in Guymon to discuss commodity prices, cattle prices, and agricultural technology. Sometimes, it seems that the Oklahoma Panhandle is a forgotten place, when local residents wish to make a statement, the rest of the state of Oklahoma listens. Even a century ago, people knew that this was the case. In addition, then as now, agriculture was a valuable part of the Panhandle's economy and lifeblood. (Courtesy of Lobit Studio.)

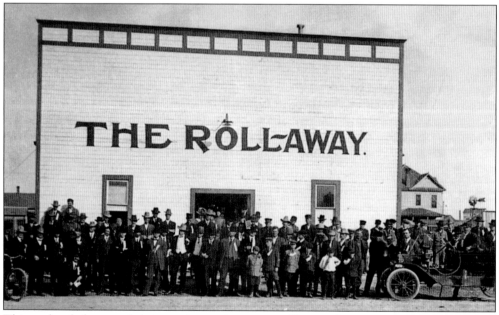

This undated photograph has two interesting aspects. First, it shows an entertainment venue in Guymon, The Roll-Away, a roller-skating rink popular in the town's early years. Second, the men gathered in the photograph have come to town to participate in a conference on irrigation, an important aspect of ranching and farming in the area. Even today, irrigation provides much-needed water on the arid High Plains. That water comes from the Ogallala Aquifer. (Courtesy of Guymon Public Library and Arts Center.)

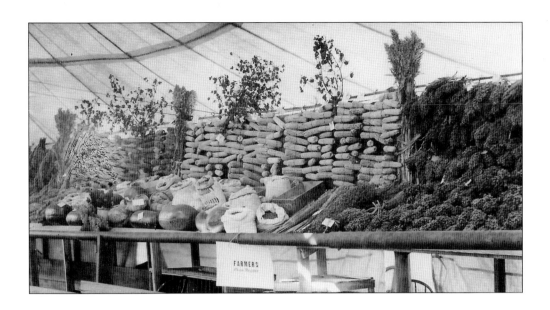

The Texas County Fairgrounds have served as the location for many events: county fairs, circuses, carnivals, home shows, coin and gun shows, craft shows, trade shows, and commencement exercises. Through the years, the nature and name of the county fair have changed. Initially, the fair was called the Farmer's Institute. The photograph above of farm and garden produce was taken on October 14, 1908. Below, many children attend the Farmer's Institute in the early 1900s. The modern county fair occurs in August. (Above, courtesy of Lobit Studio; below, Pioneer Showcase.)

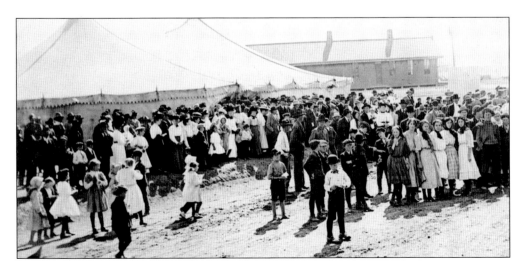

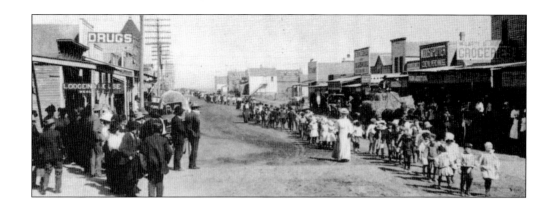

During each Farmer's Institute, a parade would be held featuring Guymon's children, shown above. The parade followed Main Street and wound its way to the east side of town—the original location of the fairgrounds. In the photograph below, the Free Fair Building is under construction in the 1950s on the west side of town. It was destroyed in the 1970s to make way for a new fair building: a large main-event center with an open floor plan. (Above, courtesy of Pioneer Showcase; below, Sandra and Dwayne Fronterhouse.)

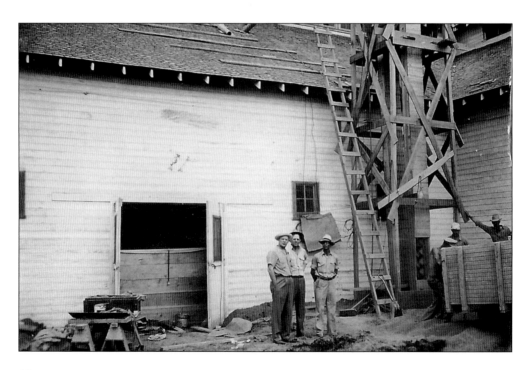

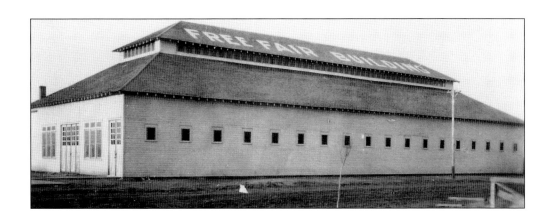

The Free Fair Building is shown (above) after completion. Currently, the fairgrounds sit on the west side of town, just to the east of Thompson Park, and features the main-event center, the Texas County Activity Center (below), several barns for showing and housing livestock, and a large parking lot. Many shows and programs draw people to the activity center, including gun shows, craft fairs, home shows, carnivals, circuses, and community and business dinners and meetings. (Above, courtesy of Pioneer Showcase; below, Tito Aznar.)

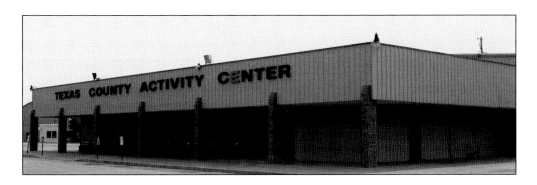

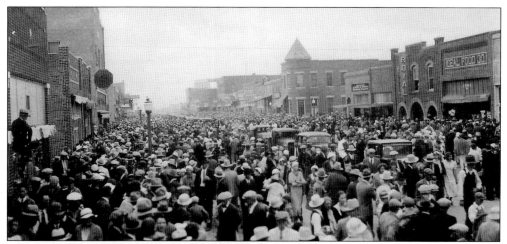

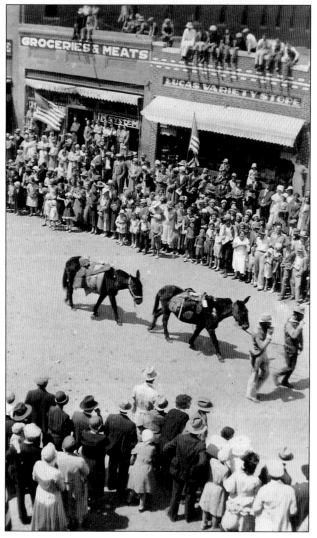

In the early 1930s, during the Great Depression, Guymon developed a celebration to add revelry to an otherwise stressful, dreary time. Businessmen Orville Nash, Shorty Rhoton, Carl Hunt, and Bo Belcher thought that a celebration would draw people to town and increase sales. The junior chamber of commerce contacted the history department at the University of Oklahoma in Norman to determine a good day to celebrate Oklahoma. They decided on May 2, the anniversary of the 1890 Organic Act that made the Panhandle part of Oklahoma Territory. The first Pioneer Days in 1933 featured a parade, rodeo, free food, dances, music, speeches, and contests, such as a whisker contest, a costume contest, and the oldest-attendee contest. Organizers encouraged longtime Panhandle residents to attend, and at least 15,000 people crowded downtown. Pioneer Days is still an annual spring event and Guymon's number-one calling card. (Above, courtesy of Lobit Studio; at left, the Hurliman Collection, No Man's Land Museum.)

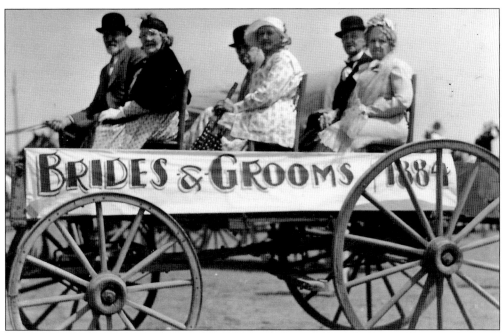

At the first Pioneer Days celebration in 1933, organizers conceived of a parade entry featuring married couples celebrating their golden anniversary that year. L.W. and Rose Shields (left), Jim and Lizzie Nichols (center), and John and Adia Violes (bringing up the rear) climbed aboard the spring wagon to prove that love can indeed last half a century. Celebrating the Oklahoma Panhandle's pioneer heritage for 80 years now, Guymon's Pioneer Days continues each May. It is highly anticipated by all citizens of the area, and, yes, a parade is still an integral part of the event. (Courtesy of Dean and Joann Kear.)

Each year, beginning in 1940, a woman who can trace her Oklahoma Panhandle heritage to the late 1800s or early 1900s is selected to be the Pioneer Days Queen. This selection honors the ancestors of the Panhandle pioneers who struggled through tough times to survive and thrive and establish "civilization" in what certainly used to be the Wild West of No Man's Land. Shown here is Josie Westmoreland Hitch, the 1942 Pioneer Days Queen. (Courtesy of No Man's Land Museum and Pioneer Showcase.)

In this 1934 photograph, the Alexander family, atop their two horses in front, gets into the spirit of Pioneer Days. This was the second year of the festival celebrating the Panhandle's frontier heritage. Clarence and Sue Alexander and their young son saddle up to ride in the parade. Sue, decked out in female pioneer attire, rides sidesaddle. Her husband has affected a Native American look. Guymon still hosts Pioneer Days, a weeklong event that everyone greatly anticipates. (Courtesy of the Hurliman Collection, No Man's Land Museum.)

This great photograph features Newt Huddleston, the father of Sandra Fronterhouse, on the bucking barrel entry in a 1950s Pioneer Days parade. Begun in 1933, Pioneer Days is an annual May event celebrating the region's pioneer and frontier heritage. A Main Street parade, rodeo, barbeques, breakfasts, contests, dances, and Western attire have always been part and parcel of this weeklong festival of fun and history. (Courtesy of Sandra and Dwayne Fronterhouse.)

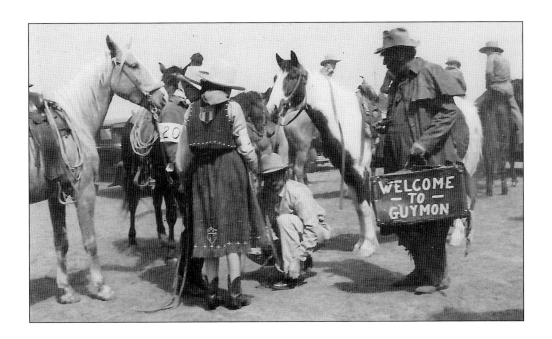

Pioneer Days, a mainstay event in Guymon, generally requires participants to dress like pioneers and cowboys—it is a Western party after all. Started in 1933, the celebration honors the pioneers who settled the Panhandle. These photographs from the 1930s show people getting ready to ride in the parade. Below, Cloron (second from left) and Dow Edgington (wearing a headband), along with their trick mule, prepare to join in and entertain during the May 2, 1933, Pioneer Days parade. (Both, courtesy of Lobit Studio.)

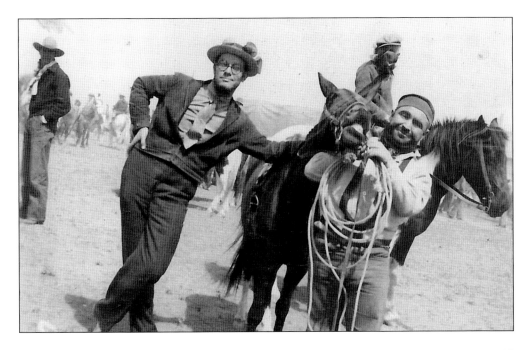

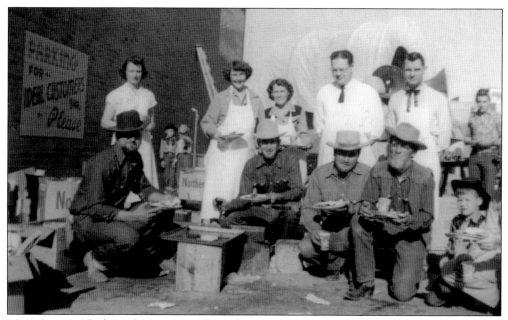

Main Street's Ideal Food Store, owned by Harold Colgin, generously provided coffee to those citizens working nearly 24-hour days in preparation for Pioneer Days. In conjunction with the grocery store, the Harold Gibson family of nearby Hardesty eventually began to provide a hearty early-morning breakfast for workers and community members. The Pioneer Days "Old Timers" Breakfast is a tradition that continues today, perennially beginning bright and early at 5:30 a.m. Colgin is seen here in the string bow tie. (Courtesy of Sandra and Dwayne Fronterhouse.)

Guymon has always heavily promoted its Pioneer Days celebration. Here, "Lobo" Jim Wilcox sits astride his obviously shy horse, Smoky. Carrying 20 pounds of mail, they participated in a "Pony Express" ride between Guymon and Oklahoma City (273 miles) in four days in 1937 to publicize the upcoming annual frontier heritage event. Pioneer Days' participants must dress as Westerners, and Wilcox is certainly decked out in deluxe cowboy gear. (Courtesy of Dean and Joann Kear.)

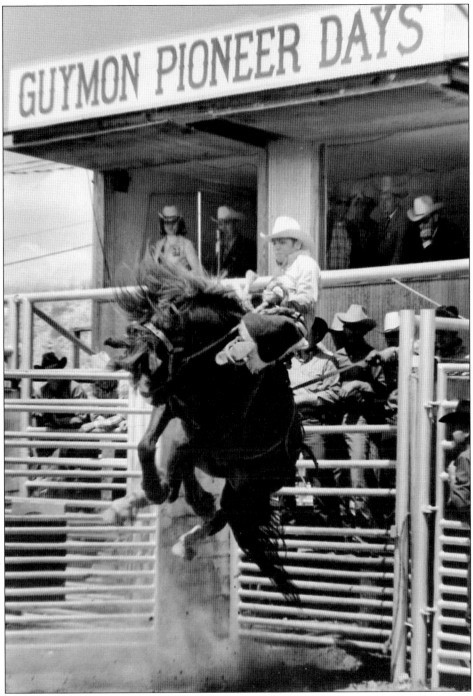

The centerpiece of Guymon's Pioneer Days is the rodeo, an event big enough to receive national television exposure. Professional rodeo cowboys come to compete in the events held at Hitch Arena on the west side of town. Here, world champion Phil Lyne sits atop a rank saddle bronc right outside the chute at the 1970 Pioneer Days Rodeo. (Courtesy of Lobit Studio.)

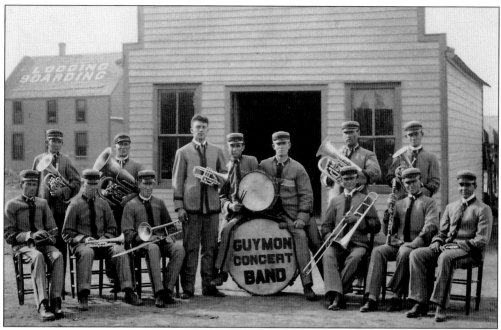

The Guymon Town Band started around 1909 and put on concerts periodically to entertain residents. Many of the musicians had their own businesses in town, but they found the time to contribute to cultural entertainment in the rather raw and remote part of the new state of Oklahoma. Clarinet player Steve Safranko (front row, second from right) owned The Model Department Store and played a major role in starting the first Catholic parish in the Oklahoma Panhandle in Guymon. The owner of Lucas' Variety Store, Andy Lucas (back row, second from right), played the euphonium in the band. (Courtesy of Lobit Studio.)

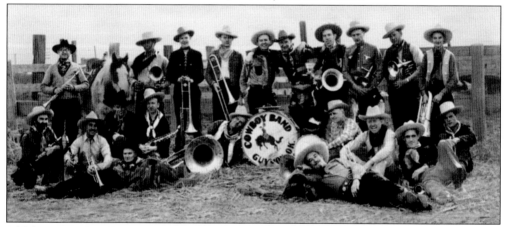

Oklahoma Panhandle residents have had to create their own entertainment. Early Pioneer Day celebrations were incomplete without Guymon's Cowboy Band. The members traveled to nearby communities, advertising Pioneer Days by playing and singing. In 1933, twenty-three musicians, dancers, and vocalists toured the area. An offshoot of the Guymon Municipal Band, the Cowboy Band took the "cowboy" part to heart. Members grew beards and dressed like cowboys. Audiences loved their renditions of "Home on the Range," "Marie," and "Old Faithful." Many members joined the military during World War II, so the band went into "forced retirement," only to be brought back to life for the 1946 Pioneer Days. (Courtesy of Pioneer Showcase.)

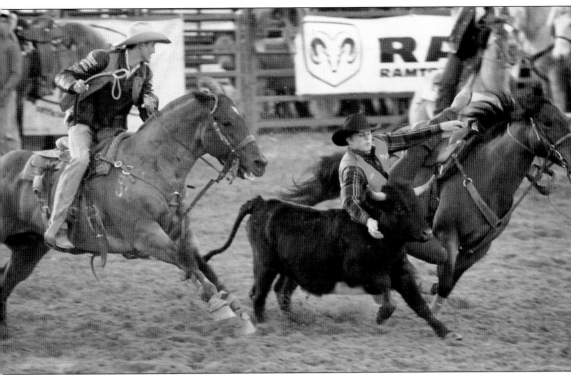

In honor of the longtime rodeo coach and chemistry professor at Goodwell's Oklahoma Panhandle State University (OPSU), Lynn Gardner, the Doc Gardner Memorial Rodeo has long been a part of OPSU and Guymon. The rodeo was first held in Goodwell, but because of its growth, Guymon began hosting it. At the April event, about 600 college cowboy and cowgirl athletes compete for individual and team standings in order to participate in the College National Finals Rodeo (CNFR) held in Wyoming each June. OPSU won the CNFR title in 1997, 1998, 2000, 2004, and 2013. Here, Joe Frost, an OPSU junior from Randlett, Utah, wrestles a steer at the 2013 rodeo, voted the Central Plains Rodeo Region's Best Rodeo of the Year. (Courtesy of Sage Fischer.)

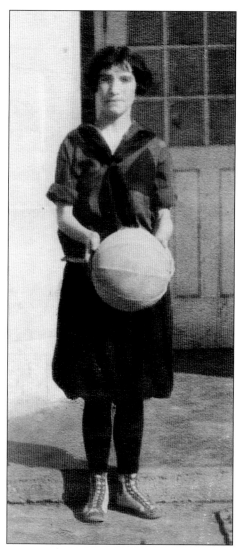

Guymon has always emphasized sports, especially among its young people. One of the earliest female athletes was Flossie Heard, a high school basketball player. She is seen at the left dressed in her official Guymon uniform. Note the prim and proper long hosiery, the tied necktie, and bloomer bottoms that a lady would wear playing a "man's sport." The ball seems bigger than the one used today, or perhaps Flossie was particularly petite. Heard later married William King, lived as a homemaker in the Guymon area all her life, and had six children. Basketball has long been a part of Guymon, whether organized through Kid's Inc., a city league, or public schools. Below, the 1910 men's high school basketball team poses for the camera. (At left, courtesy of the King family; below, No Man's Land Museum.)

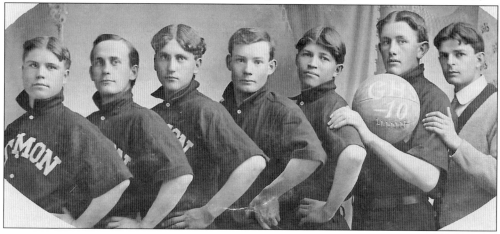

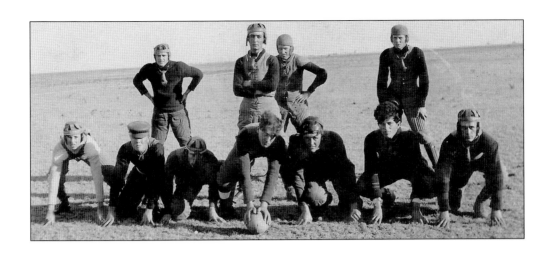

Guymon has always put men on the gridiron, even as early as 1909, as seen above. If the public school could not or did not support a team, local churches provided teams. Apparently, early teams were pretty good. The 1913 Guymon team shown below went undefeated and won a championship title. (Above, courtesy of Pioneer Showcase; below, Dean and Joann Kear.)

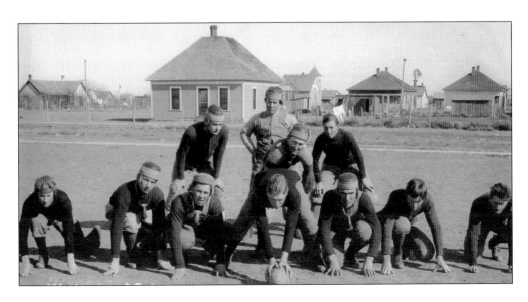

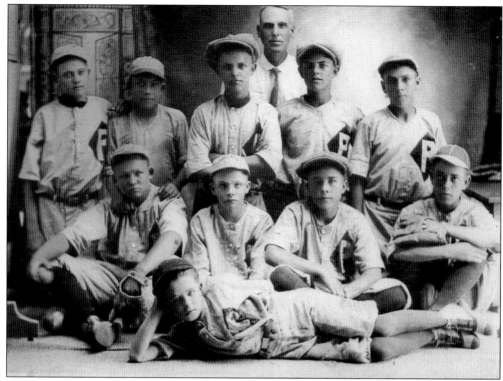

Baseball has been a popular sport on the American frontier since Abner Doubleday "invented" the game in 1839. Local, homegrown clubs existed in most every Western community, and Guymon was no exception. Above, the members of the Presbyterian Church's Sunday school team of 1922, the Live Wires, proudly pose for a photograph with their Sunday school teacher and coach, J.R. Howsley. Note the "P" on their uniforms. The reclining boy in the front is batboy Bob Lancastor. Below, the 1912 Guymon school team strikes a postgame pose near the bleachers. It had just beaten the high school team from Texhoma, Oklahoma, 5-3. (Above, courtesy of Joann and Mike Holland and No Man's Land Museum; below, Bill and Lauretta Garrison.)

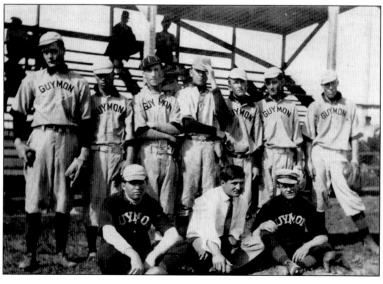

Guymon's tradition of maintaining fine sports organizations continues today, epitomized by Christian Arbuthnot (right). As he matured into high school, Arbuthnot has become quite the athlete, and he got his sporting start at Kid's Inc., organized in Guymon in 1955 under the leadership of Jim Cross and Carl McKinnon. Kid's Inc. first developed a baseball program, followed by basketball, for boys. Anna Marie Holland Livingston, a student at Oklahoma Panhandle State University in Goodwell, fashioned a girls' sports program. Today, Kid's Inc. has its own sporting venues in town and hosts cheerleading, baseball, softball, football, basketball, and soccer. (At right, courtesy of Duke and Tara Arbuthnot; below, Beth McKee.)

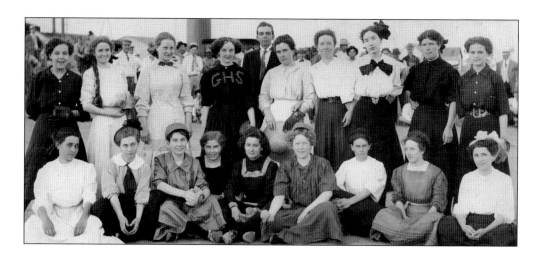

Of course, high school cultural events, like drama, debate, and music, have been just as important as high school and community athletic contests. For example, in 1911, the first dramatic production, *A Case of Suspension,* was mounted by Guymon schools. The school sponsored two literary societies, the Delphinians and the Ionians. Posing in the photograph above is the 1917 Guymon High School Ladies Glee Club, perhaps after having played baseball; note the gloves that some of the girls wear. In the photograph below, the 1950 high school band includes many musicians. Today, music continues to be an integral part of young people's education in Guymon schools. (Above, courtesy of Diane Roberts; below, Leonene and Carroll Gribble.)

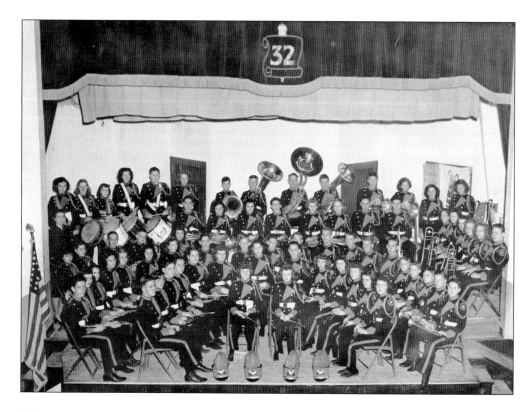

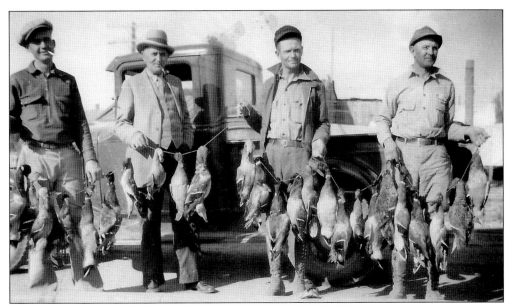

These 1920s photographs prove that the Beaver River north of Guymon had water once upon a time. Posing above are, from left to right, Donald Hughes, L.W. Shields, Floyd Kear, and Oral Shields. They show off ducks that they bagged after a morning hunt along the river. Below, Kear (right) and L.W. Shields pose outside the Guymon ice plant with ducks taken during another hunting expedition. In the past, migratory birds found water in the Panhandle. Today, however, with usual drought conditions and the abundance of irrigation, not many open bodies of water are left, including the Beaver River. (Both, courtesy of Dean and Joann Kear.)

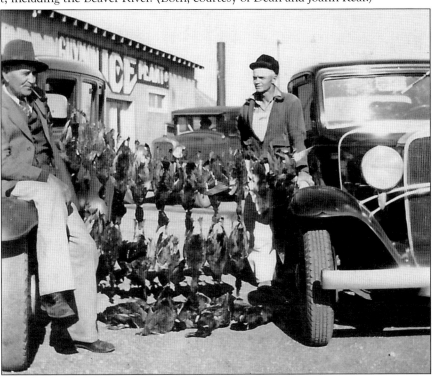

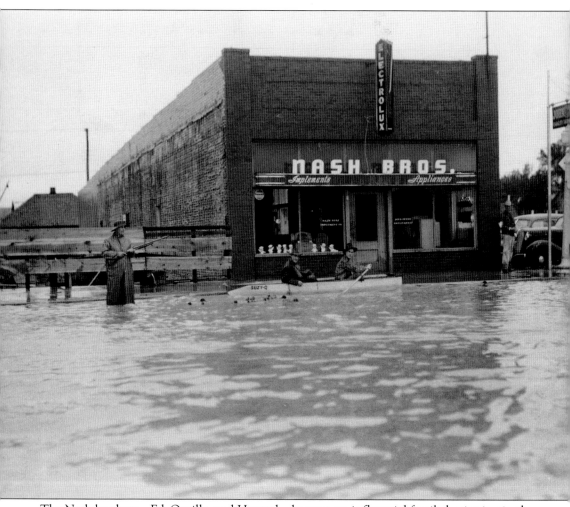

The Nash brothers—Ed, Orville, and Howard—became an influential family beginning in the 1930s, and they were known as fun-loving men. Originally, the family had its own ranch east of Guymon, but it started business ventures, first selling tractors and automobiles, then branching out to selling appliances, butane, airplanes, and fertilizer. Here, the brothers dressed in rain gear have found a boat, launched it on a rarely flooded Guymon street, floated some duck decoys, and are ready to shoot at the first flock of ducks that dares to fly by. (Courtesy of Pioneer Showcase.)

Guymon hosts "fight cancer" events all year long, the main one being the American Cancer Society Relay for Life, a 24-hour celebration of life begun in July 1996 at Guymon High School's Tiger Stadium. That first event included a survivors' lap of the track (shown here). Other highlights include playing games, remembering loved ones and lighting *luminarias* in their honor, and enjoying live musical performances. Fundraising activities take place all year, including bake sales, car washes, raffles, and dinners. Panhandle citizens stand together to battle cancer, and they take the fight very seriously. (Courtesy of Sheila Blankenship.)

To secure Central Airlines' commercial flight service in the 1950s, the Guymon airport was required to have an easement of at least 100 feet, north to south, on the quarter of land adjacent to the landing field. This land was owned by the R.S. Coon estate. Hearing of Guymon's concern and need, estate executors agreed to sell the land for $25 an acre. Today, 300 acres of that land is the C.A. Sullivan Game Reserve, where small herds of elk, buffalo, and exotic cattle live. (Courtesy of Tito Aznar.)

Guymon supports a state-recognized farmers' market each Saturday morning from June through September. Here, farmers, gardeners, and crafters sell homemade items and foodstuffs, including handcrafted soap, cupcakes, tomatoes, and melons, as well as offering chickens. Held on the west side of the Texas County Courthouse in the shade afforded by big trees and the building itself, the market attracts people who just like to look and customers who come for the fresh produce and tasty baked goods. (Both, courtesy of Melyn Johnson.)

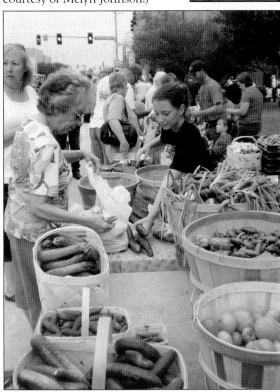

Iron Thunder, the local motorcycle club, hosts the Five-State Run each May. The 2003 premiere event was attended by 110 bikers; 10 years later, nearly 1,000 bikes participated. This rally covers twice as many miles as most rallies, and those 300 miles take riders on highways through five states: Texas, Kansas, Oklahoma, New Mexico, and Colorado. The party starts with Friday evening registration that includes "The Outback," a downtown BBQ feed with live bands and a blocks-long motorcycle display. The ride ensues Saturday morning, and the weekend winds down Saturday night with a banquet. Iron Thunder is not always just thinking of fun and rallies; the organization gives money to help local people during times of illness. (Courtesy of Beth McKee.)

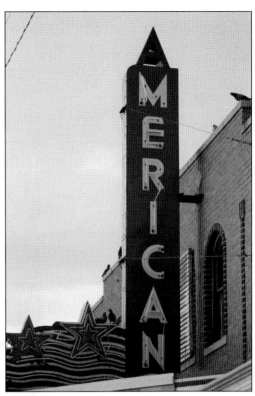

Michael and Kristy Patterson initiated a community theater at Academy School in 1979. By 1983, Guymon Community Theater was housed in the remodeled American Theater, shown at right. There have been 112 shows in 34 seasons. From the 189 reclining, padded seats, theatergoers enjoy musicals, comedies, and dramas, all accomplished with volunteers. William Moses owned the town plot in 1904, and the theater was built there between 1927 and 1930. Grants have refurbished the building, including the following projects: adding dressing rooms, restrooms, and air-conditioning; supplying a grand drape; and installing professional lighting. Below, Ian McCulloch (left) and Michael Patterson appear in a production of *Little Shop of Horrors.* (At right, courtesy of Beth McKee; below, Joyce Smith.)

A common local event is the *quinceañera*, honoring a Hispanic girl's 15th birthday, when she symbolically leaves childhood and enters womanhood. The girl dresses in an elegant white dress, selects her "court"—14 girls and 14 boys, less than age 15—and chooses an escort. Each celebration begins with a Catholic mass, at which the young lady wears a simple headpiece (later traded for a tiara) and honors the Virgin Mary by laying flowers at her statue. A party follows, and the first dance is always reserved for the girl and her father. These photographs feature Nehyma Martinez and her court. (Both, courtesy of Martha Hinojosa.)

Prompted by the State Historical Preservation Office's annual conference held in Guymon in 2011, the This Place Matters Tour series began in 2012. Organized by residents and spearheaded by Melyn Johnson from the Main Street Guymon office, tours focus on local architectural gems, such as the Latham House, Danholt, the Dale Hotel, and the old high school. Above, Ann and Jim Grocholski stand on the porch of the Stanfield house, one of five unique Guymon structures featured in the 2012 tour; they are ready to show guests through the home. That tour garnered Oklahoma State Historical Preservation Office Awards of Merit for Melyn and the organizers, including Sara Jane Richter (pictured below, far right, in the lobby of the Dale Hotel) for her research and presentation on the Hay Meadow Massacre, which occurred just north of Guymon in 1888. (Both, courtesy of Melyn Johnson.)

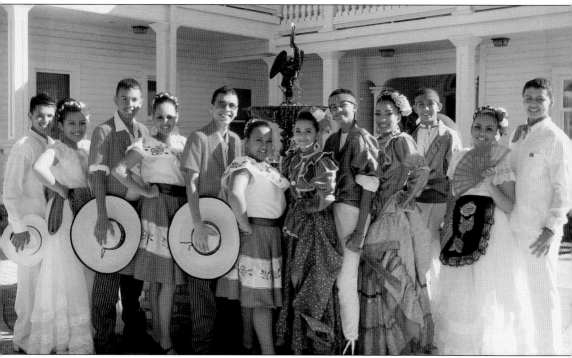

Foley, Alabama, is Guymon's sister city. In 2000, the Oklahoma Board of Convention and Tourism and the City of Guymon wished to add Panhandle events to their calendars. A board member, Melyn Johnson, attended an Alabama tourism conference and met someone from Foley. They determined that Guymon and Foley should create a cultural exchange. Heritage Harbor Days was born in 2001 when Foley brought shrimpers, a gospel choir, gumbo, and a Helen Keller impersonator to Guymon. To bring the Panhandle to Foley, Guymon took cowboys, Mexican dancers, buffalo soldiers, Kiowa Indians, burritos, and guacamole in 2002. (Both, courtesy of Teri Mora.)

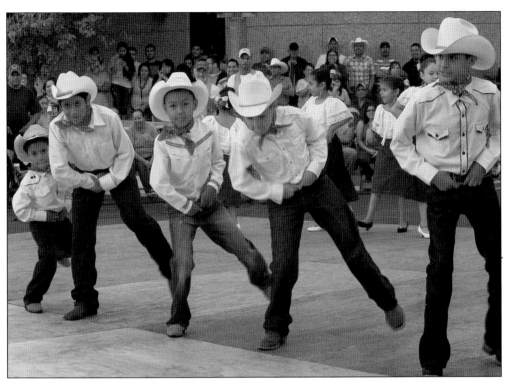

Guymon's Mexican community sought to ease tensions with and unify ties to local law enforcement 15 years ago. The Hispanic Advisory Board started slowly, hosting the first Fiesta in No Man's Land Park. The event succeeded, and it was well attended by Hispanics and non-Hispanics. Police officers did not just patrol the area, but attended in uniform and participated. As a result of this effort, cultural tensions eased. September's Fiesta focuses on food and music. Here, local dancers perform. Oklahoma Panhandle State University, in nearby Goodwell, awards one-year scholarships to the young Hispanics chosen as king and queen each year. (Both, courtesy of Beth McKee.)

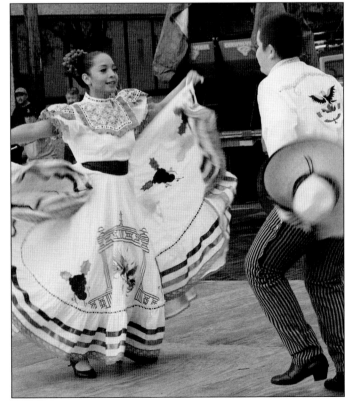

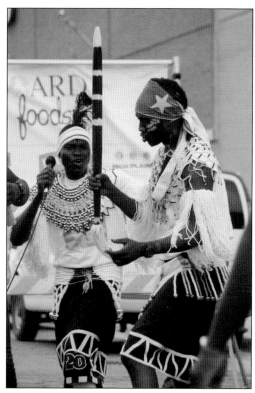

Guymon's first Azuma: An African Celebration occurred on August 10, 2013. Initiated by Melyn Johnson of Main Street Guymon, the African expatriate population organized the event to celebrate African culture, food, dance, and music. Sponsors expected 100 guests, but over 400 enjoyed the energy-packed afternoon. Recently, Guymon has welcomed immigrants from Eretria, South Sudan, Nigeria, Tanzania, Ethiopia, Zimbabwe, and The Gambia. Among the South Sudanese men were orphaned and displaced Lost Boys, who suffered tremendously during and after the Second Sudanese War (1983–2005). (Both, courtesy of Beth McKee.)

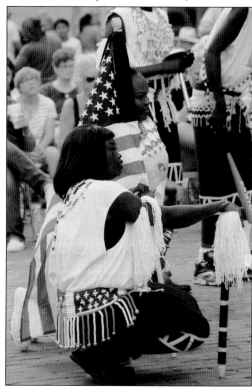

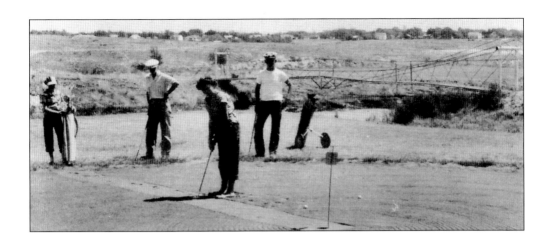

Because of the temperate climate and abundant sunshine, Guymon's Sunset Hills Golf Course is the perfect place to play a round. Located near Sunset Lake, the 6,236-yard, par-71 course, with a slope of 117, is one of the premier courses in Oklahoma. The 18-hole public course has a United States Golf Association course rating of 69 and possesses the minimum requirements to host an NCAA tournament. The bentgrass greens are maintained year-round. Golfers can take advantage of irrigated tee boxes, a driving range, and chipping/putting greens. By comparing these two photographs, one can tell how much the course has improved through the years. (Above, courtesy of Lobit Studio; below, Tito Aznar.)

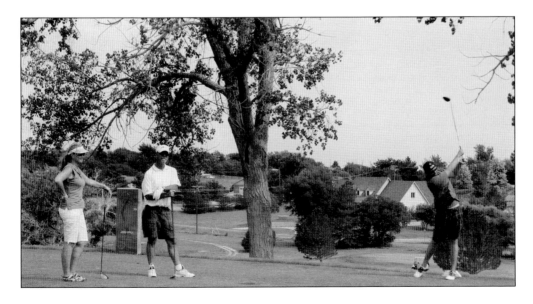

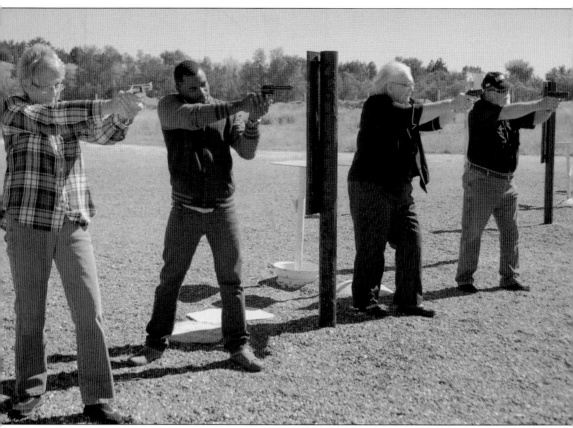

North of Thompson Park, the Guymon police shooting range is available to No Man's Land Rifle and Pistol Club members. Nestled in a canyon with remote access, it accommodates pistols and .22-caliber rifles. In 2013, the club wanted to relocate, but the selected land was too close to the airport for safety. Club members reapply for membership each year and can bring guests to the facility. Hosting various shooting competitions throughout the year, the club invites any National Rifle Association member to join. Shown here aiming their pistols at the targets are, from left to right, Linda Lear, Jihad' Wright, Sara Jane Richter, and Rex Lear. The Lears and Richter are club members, and Mr. Wright was their guest that autumn day. (Courtesy of Tito Aznar.)

Thompson Park is the largest of the 13 parks in town. It features Sunset Lake, which is stocked with trout and catfish. The city bought the land on October 22, 1946, and named it Municipal Park. It was then dubbed Sunset Park, only to be changed again to Thompson Park to honor Grady Thompson, who planned the park and its landscaping. Pavilion-covered picnic tables, a miniature train for summertime rides (below), a disc golf course, a paved walking/running trail, shady trees, ducks and geese, and playground equipment make this park popular. (Both, courtesy of Tito Aznar.)

DISCOVER THOUSANDS OF LOCAL HISTORY BOOKS
FEATURING MILLIONS OF VINTAGE IMAGES

Arcadia Publishing, the leading local history publisher in the United States, is committed to making history accessible and meaningful through publishing books that celebrate and preserve the heritage of America's people and places.

Find more books like this at
www.arcadiapublishing.com

Search for your hometown history, your old stomping grounds, and even your favorite sports team.

Consistent with our mission to preserve history on a local level, this book was printed in South Carolina on American-made paper and manufactured entirely in the United States. Products carrying the accredited Forest Stewardship Council (FSC) label are printed on 100 percent FSC-certified paper.

MADE IN THE USA